IMAGES
of Rail

MATTOON AND CHARLESTON
AREA RAILROADS

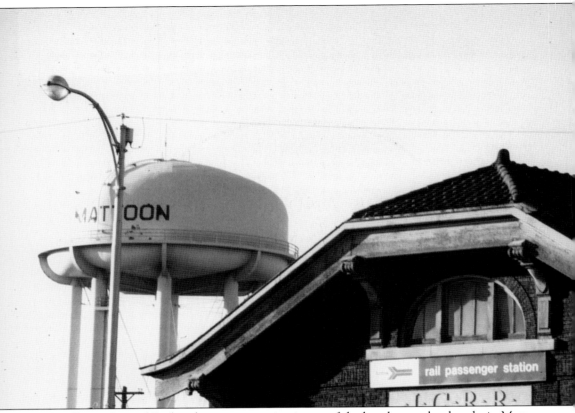

The Illinois Central Railroad passenger station is one of the best-known landmarks in Mattoon. Thousands have passed through its doors, and Ulysses S. Grant took command of his first troops during the Civil War near here. It is now owned by the city of Mattoon and used by Amtrak, and the Coles County Historical Society plans to establish a museum in the station. (Photograph by Craig Sanders.)

On the cover: For most of the nation's history, soldiers went off to war on a train. At times, the local soldiers were given a grand send-off by the townspeople. And so it was during World War I when dozens of Charleston residents bid farewell to local men who had just been inducted into the United States Army. The soon-to-be soldiers boarded a Big Four Railroad train. (Courtesy of Nancy Easter-Shick collection.)

IMAGES
of Rail

MATTOON AND CHARLESTON AREA RAILROADS

Craig Sanders

ARCADIA
PUBLISHING

Published by Arcadia Publishing
Charleston SC, Chicago IL, Portsmouth NH, San Francisco CA

Printed in the United States of America

Library of Congress Catalog Card Number: 2008920514

For all general information contact Arcadia Publishing at:
Telephone 843-853-2070
Fax 843-853-0044
E-mail sales@arcadiapublishing.com
For customer service and orders:
Toll-Free 1-888-313-2665

Visit us on the Internet at www.arcadiapublishing.com

*To Walter Sanders, my father, and the memory
of my mother, Marilyn Jane Sanders*

CONTENTS

ACKNOWLEDGMENTS

As a boy growing up in Mattoon, railroads were a part of my daily life. I could see the Illinois Central Railroad yard and main line from my backyard, and it was common to hear locomotive horns of Illinois Central and New York Central System trains at all hours of the day. As an infant in my mother's arms, I boarded a New York Central train in Mattoon in 1953, bound for St. Louis and my first train ride.

This book is a tribute to the railroads of Mattoon and its sister city, Charleston, as well as those that served the surrounding area. Although some of these railroads are still used today, others are nothing more than memories.

I want to thank my father, Walter Sanders, for giving me the idea to do this book and for buttonholing people he knew in search of photographs. That led me to Nancy Easter-Shick, a local historian who provided many photographs and the history of railroads in Charleston. Nancy Henry at the Mattoon Public Library was most helpful in helping me find photographs and information. Another key contributor to this book was Thomas French, whose father and grandfather both spent their careers working for the Illinois Central Railroad. I wish to thank the following who contributed photographs to this book: Lawrence Baggerly, Paul Burgess, Bob Bennett, Mark Camp, Donald Cleveland, John Fuller, Glenn Hite, Dwight Long, Sheldon Lustig, James McMullen, Robert Oliphant, Steve Patterson, Jeff Pletcher, Richard Record Jr., Edward Ribinskas, Lloyd Stagner, Marty Surdyk, David Tiffany, Leland Warren, and Jay Williams. A special thanks goes to the Coles County Historical Society, Mattoon Public Library, and Denver Public Library for allowing me to use photographs from their collections.

I also would like to thank Jeff Ruetsche and Ann Marie Lonsdale, my editors at Arcadia Publishing, and publisher John Pearson for their assistance by answering my many questions. Finally, I owe a very special thanks to my wife, Mary Ann Whitley, who copy edited the manuscript and provided encouragement and support throughout. The responsibility for any errors or omissions lies solely with the author.

INTRODUCTION

In the 1830s, getting somewhere was measured in weeks and months in east central Illinois. The first roads were paths—called traces—that had been used by Native Americans. Coles County's first permanent road—the modern Old State Road—was built in 1831 between Paris and Shelbyville via Charleston. At least four other roads were built during this period, but they were poorly maintained and impassable during wet weather.

Native Americans long had lived in this region of rich prairie land and plentiful oak and hickory forests but were driven out in the early 1830s following two major battles with militia groups in the hills along the Embarras River near Lake Charleston.

To spur development and improve transportation on the largely unpopulated prairie, the Illinois General Assembly approved the Internal Improvements Act of 1837. The law authorized issuance of $10 million in bonds, 90 percent of which were earmarked for railroad construction. This included $3.5 million for a central railroad between Cairo, at the confluence of the Mississippi and Ohio Rivers, and Galena in northwestern Illinois.

Legislators envisioned a 1,300-mile railroad network with five east-west lines. Three of those lines would terminate at the Mississippi River port of Alton, then the state's largest city. One railroad was to link Alton and Paris, a village near the Illinois-Indiana border. Hoping to be served by that railroad was Charleston, population 200 and the Coles County seat since 1831.

The Internal Improvements Act collapsed during the Panic of 1837. Only one railroad, a portion of the Northern Cross Railroad west of Springfield, had been built when the program was cancelled in 1841. Subsequent efforts to develop the central railroad failed to materialize.

Illinois senator Stephen A. Douglas sponsored a bill signed by Pres. Millard Fillmore in September 1850, granting public lands for a railroad right-of-way between Cairo and Dunleith (East Dubuque), with a branch to Chicago joining the main line just north of Centralia.

The Illinois General Assembly approved a charter in February 1851 for the Illinois Central Railroad (IC), America's first private railroad built on public land. A month earlier the legislature had chartered the Terre Haute and Alton Railroad (TH&A), which proposed building on a route approximating the stillborn Alton–Paris railroad.

By 1852 rumors had reached Coles County that the IC and TH&A would cross 10 miles west of Charleston. The IC was surveyed through the county in March 1853. TH&A surveyors arrived later that spring. The IC sought the straightest route with little regard to existing towns, but the TH&A was more receptive to catering to settlers between its terminals.

The two railroads would cross on a ridge inhabited only by grazing cattle. The earliest settlement near here had occurred in 1826 in the forests along the Little Wabash River several

miles to the southwest. The first settlers were from Kentucky and had remained in the forests because they feared the prairie was a source of fever.

Ebenezer Noyes foresaw a thriving town springing up around the railroad crossing. Noyes, Charles Jones, Davis Carpenter Jr., Usher Linder, James Cunningham, Stephen Dole, John Cunningham, John Allison, Elisha Linder, H. Q. Sanderson, Harrison Messer, Samuel Richardson, William Tuell, and Josiah Hunt bought land at the site for $2.50 an acre. After John Meadows surveyed the site on December 12, 1854, locals dubbed it Pegtown after the pegs that Meadows had placed in the ground to mark the lots. This was the spot that later became Mattoon.

Construction of the IC and the TH&A had begun in 1852. Early Illinois railroad builders faced daunting challenges. Much of the territory was wilderness. The Chicago branch did not pass through any community of more than 100 residents. Most materials needed for railroad construction, including labor, had to be imported from outside the state.

How Mattoon got its name is shrouded in mystery. One whimsical account is that William B. Mattoon, who supervised the building of the TH&A, won naming rights in a card game. Another story is that Mattoon offered to bet Roswell B. Mason, chief engineer of the IC, a substantial sum that the TH&A would reach the crossing first. Mason replied that he was not a betting man and would not wager money but counteroffered that the first company to reach the crossing could name the station. Another explanation is that the town's founders gathered in a Charleston hotel on May 15, 1855, and named the town after Mattoon in hopes that he would bestow some of his wealth on the new community.

Another puzzle is which railroad reached the crossing first. In a 1950 history of the IC, Carlton Corliss wrote that the IC won the race, reaching the crossing point on June 25, 1855. Mason was said to have been so grateful to Mattoon for initiating the tracklaying contest, which caused his men to redouble their efforts, that he named the station in Mattoon's honor. Yet in a 1905 history of Coles County, Charles Edward Wilson wrote that the TH&A reached the crossing four days ahead of the IC. Homer Cooper, who published a history of Mattoon in 1914, also asserted that the TH&A reached the town first. Cooper wrote that the last nine miles of the TH&A track was laid on ground that had not been graded.

By Cooper's account, the first train to reach Mattoon arrived about noon on June 9, 1855, to the cheers of a crowd of 3,000. William B. Mattoon stood atop a freight car and told the celebrants that the train had brought an unlimited supply of beer and whiskey. A week later, IC crews completed the crossing at Mattoon.

Construction of the TH&A halted at Mattoon for several months before its completion on March 1, 1856. The last rail of the Chicago branch of the IC was spiked into place on September 27, 1856.

By the 1850s, St. Louis was rapidly eclipsing neighboring Alton as a commercial center. The TH&A acquired the charter of the Belleville and Illinoistown Railroad in February 1854 and completed a line between Alton and Illinoistown (later renamed East St. Louis) in October 1856. The now named Terre Haute, Alton and St. Louis Railroad (THA&StL) emphasized Terre Haute–St. Louis traffic, and Alton became a destination of secondary importance.

The THA&StL connected with the Terre Haute and Richmond Railroad, which had opened between Terre Haute and Indianapolis in 1852. In October 1859, the two railroads in tandem with the Indianapolis and Bellefontaine Railroad, and the Indiana Central Railway established a through route between St. Louis and the East.

The THA&StL defaulted on its bonds in 1859 and reorganized in 1862 as the St. Louis, Alton and Terre Haute Railroad (StLA&TH). A Cincinnati investment group leased the StLA&TH and placed it under the management of the Indianapolis and St. Louis Railroad (I&StL). The I&StL entered receivership in 1882 and fell under the control of the Cleveland, Columbus, Cincinnati and Indianapolis Railway. A June 1889 merger created the Cleveland, Cincinnati, Chicago and St. Louis Railway (Big Four).

The Vanderbilt family, which owned the New York Central Railroad (NYC), heavily invested in the Big Four Railroad and soon had stock control of it. The Big Four Railroad offered through

service with the Vanderbilt-controlled Lake Shore and Michigan Southern Railway at Cleveland. The NYC leased the Big Four on February 1, 1930.

Following the Civil War, the IC acquired a network of Southern railroads to create a route linking the Great Lakes and the Gulf of Mexico. Travelers had to take a ferry between Cairo, Illinois, and Fillmore, Kentucky, until the October 29, 1889, opening of a bridge over the Ohio River.

Charters were issued in 1857 for a proposed Mattoon–Mount Vernon, Indiana, railroad. Nothing came of it until the Grayville and Mattoon Railroad (G&M) incorporated in 1876. Construction began in September between Newton and Olney. A year later, the railroad had been completed between Mattoon and Newton. The G&M opened on July 4, 1878, between Mattoon and Parkersburg.

The Decatur, Sullivan and Mattoon Railroad (DS&M) was chartered on March 26, 1869, and opened between Mattoon and Hervey City in 1872. The DS&M and the Paris and Decatur Railroad (P&D) used a jointly owned seven-mile line between Hervey City and Decatur Junction, two miles south of Decatur. Trains reached Decatur on the IC.

The DS&M experienced financial troubles and for a time was operated by the P&D. By 1880, the DS&M—now named the Decatur, Mattoon and Southern Railroad—had been acquired by the Pekin, Lincoln and Decatur Railway (PL&D). The PL&D had opened between Pekin and Decatur in November 1871 and reached Peoria on March 1, 1878. The newly merged company was named the Peoria, Decatur and Evansville Railway (PD&E).

The PD&E acquired the G&M, which had opened to Evansville, Indiana, on June 1, 1882. Mattoon was halfway between Peoria and Evansville, and the PD&E built locomotive and car shops in Mattoon in 1878.

Evansville businessman Daniel J. Mackey gained control of the PD&E in 1885 and moved its headquarters from Mattoon to his hometown. An early-1890s depression sent the PD&E into receivership, and the IC purchased it on February 6, 1900, taking possession six months later.

Charleston civic leaders long had talked about bringing a second railroad to town, and residents voted in 1871 to issue $100,000 in bonds to help build the Tuscola, Charleston and Vincennes Railroad (TC&V). Only eight bonds of $1,000 each were sold, and the TC&V never advanced beyond grading a right-of-way between Charleston and Oakland.

The Toledo, Delphos and Burlington Railroad (TD&B) was formed May 23, 1879, with the goal of building a narrow-gauge line between Toledo, Ohio, and St. Louis. Charleston representatives discussed with TD&B officials building through Charleston. A Charleston construction company laid rails to Oakland in December 1880, and the line was built to Ridge Farm in late 1881. Completion of a bridge over the Wabash River enabled mixed train service to begin between Charleston and Frankfort, Indiana, on August 25, 1882.

Construction west of Charleston began in May 1881 but halted at Neoga due to financial troubles. Work resumed in spring 1882, and the railroad reached East St. Louis in late December. Another fiscal emergency stalled completion, and the East St. Louis extension did not open until May 14, 1883. Five different companies helped build or plan the Toledo–St. Louis railroad.

The now named Toledo, Cincinnati and St. Louis Railroad (TC&StL) entered receivership in August 1883 and two months later announced plans to convert to standard gauge. The track east of Charleston was converted to standard gauge in late August 1888. The last Charleston–East St. Louis narrow-gauge train operated on May 31, 1889, and the track was converted to standard gauge the next day.

A natural gas boom in Indiana helped the TC&StL regain financial health. In recognition of that good fortune the railroad adopted a three-leaf clover as its corporate symbol. Each leaf represented a state the railroad served. The Clover Leaf Route, as the railroad came to be called, emerged from receivership on June 12, 1886, with a new name, Toledo, Cincinnati and Kansas City Railroad (TC&KC).

Unable to pay its Illinois taxes in 1892, the TC&KC entered receivership and emerged on July 31, 1900, as the Toledo, St. Louis and Western Railroad (TStL&W). The company

prospered and changed its logo to a four-leaf clover. The 1907 acquisition of the Chicago and Alton Railroad turned into a financial disaster and plunged the Clover Leaf Route into its third receivership. The New York, Chicago and St. Louis Railroad (Nickel Plate Road) bought the TStL&W on June 18, 1923.

Before the Civil War, Terre Haute businessmen discussed establishing a railroad to Decatur, but little happened until construction of the P&D began in 1871. The railroad opened between Paris and Decatur Junction on December 27, 1872, serving Oakland in the northeast corner of Coles County. P&D trains used the I&StL between Paris and Terre Haute.

The general contractor who built the P&D, Robert C. Hervey, agreed to build the Peoria, Atlanta and Decatur Railroad between its namesake cities. In October 1873, Hervey formed the Paris and Terre Haute Railroad to build between Paris and Farrington a station on the Vandalia Line System seven miles west of Terre Haute.

The Paris–Farrington and Decatur–Peoria routes were completed a year later. Hervey consolidated the three companies in October 1874 into the Illinois Midland Railway (IM). The IM's financial woes led Hervey to seek receivership in a state court in September 1875. But the bondholders sought a mortgage foreclosure in federal court in December 1876. The ensuing litigation reached the United States Supreme Court in 1886.

The IM was reorganized in January 1887 as the Terre Haute and Peoria Railroad (TH&P). The Terre Haute and Indianapolis Railroad (TH&I) leased the TH&P on October 1, 1892, and folded it into the TH&I's Vandalia Line System. The Pennsylvania Railroad gained control of the TH&I in late 1895.

Coles County's most obscure railroad was the Danville, Olney and Ohio River Railroad (DOOR). Chartered on March 10, 1869, it opened as a narrow-gauge railroad between Kansas and Westfield on June 1, 1878. The DOOR was converted to standard gauge in 1881. The following year it reached Olney and in 1883 expanded north to Sidell.

Entering receivership in 1883, the DOOR was reorganized in May 1886 as the Chicago and Ohio River Railroad (C&OR) and acquired by the PD&E in August 1893. The railroad had two stops in Coles County. A flag stop for Hites in Ashmore Township was established in 1898. Hites, located east of the railroad, had a post office but little else. The station had vanished from the timetable by 1918. Another station in Coles County, Relief, was established in 1914.

The PD&E sold the C&OR to the ID&W in December 1898, and it came under control of the Cincinnati, Hamilton and Dayton Railroad. The financial struggles continued, and the C&OR had a succession of owners and names over the next three decades, including Sidell and Olney Railroad, Westfield Railroad, Kansas and Sidell Railroad, and Casey and Kansas Railroad. None of these companies prospered, and the tracks were removed in Coles County in mid-1937.

One

RAILROADS TRANSFORM
A REGION

Railroads changed east central Illinois in many ways. Improved travel brought new residents and opened new markets. No longer would farmers have to spend several days hauling grain in wagons or driving livestock to markets in St. Louis or Terre Haute, Indiana. Some farmers, though, spurned the railroads and continued going to market the old way.

A booming trade developed for fresh game—notably turkeys, deer, prairie chickens, ducks, quails, and rabbits—that was killed and sent eastward by rail. A carload a day of fresh game was being shipped from Mattoon by late 1856. But this drastically depleted the wildlife population, particularly of wild turkey and deer.

In the mid-1850s, there were just four east-west railroads in downstate Illinois. Mattoon was one of the few places with two railroads, and within a year of its founding it had more than 100 buildings. The coming of the railroads was a catalyst for population growth. Coles County grew from 9,335 residents in 1850 to 14,204 in 1860, to 25,235 in 1870, and to 34,146 in 1900.

Also migrating to the region, particularly to Mattoon, were African Americans in search of employment with the railroads or businesses that revolved around the railroads. Much of this migration occurred in the late 19th and early 20th centuries. Black residents, though, remained a small percentage of the population.

Much of the transformation wrought by the railroads was social. Historian Charles Edward Wilson wrote that an influx of women with their Yankee school marm ways exerted a "civilizing and polishing influence from 'way down East' . . . on the sons and daughters of our Kentucky, Virginia and Tennessee-born pioneers, and turn[ed] their faces about, so that they might catch new views of life."

But perhaps the most significant change was in attitudes. "The pulses of her people beat faster; their steps quickened; their horizon was enlarged; their hopes expanded, and the building of cities and of factories of various sorts, within its borders began to take form in the thoughts and plans of its citizens," wrote Wilson of the aftermath of the coming of railroads.

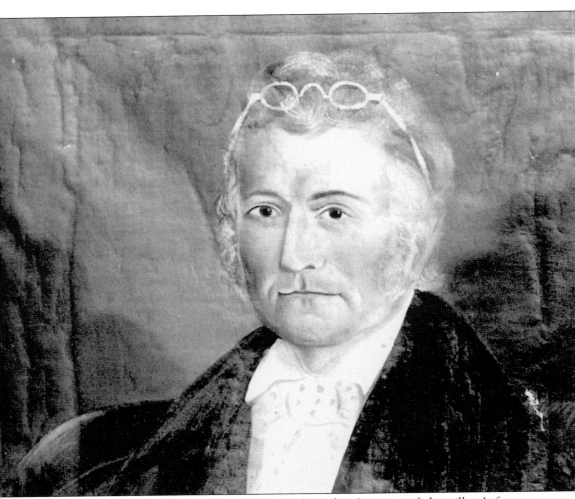

Charleston was named for Charles S. Morton (seen here), owner of the village's first store, president of its first bank, and its first postmaster. Morton and his wife moved to the area in 1829 from Lexington, Kentucky. Situated between tallgrass prairie to the west and beech and maple forests to the east, the future site of Charleston was home to Native Americans long before white settlers arrived in 1825. Created on December 25, 1830, Coles County was named for Edward Coles, the second governor of Illinois. Morton and Benjamin Parker purchased 20 acres of land that they donated to the new county government for a county seat. Charleston's founders had planned to establish the town on the Embarras River but instead chose flatter land to the west. Charleston was surveyed on April 23, 1831. That same year Morton established a post office named Coles Court House. By 1837, Charleston had a population of 200. The Eastern Illinois State Normal School (now named Eastern Illinois University) was established in Charleston in 1895 with classes beginning in 1899. (Courtesy of Nancy Easter-Shick collection.)

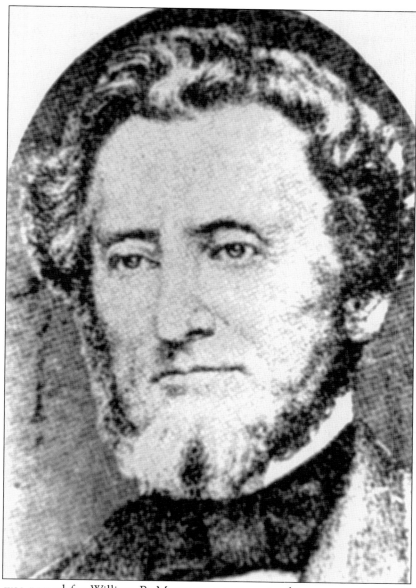

Mattoon was named for William B. Mattoon, a partner in the construction firm of Phelps, Mattoon and Barnes, which held the contract to build the Terre Haute and Alton Railroad (TH&A). Mattoon was chief construction engineer. Born in 1816 in Vienna, New York, Mattoon had a common school education and left home at age 17. After three years of working on a farm, he became a railroad track worker and, in the 1850s, a contractor. Mattoon's wealth and knack for promotion may have led the founders of Mattoon, which was surveyed on December 12, 1854, to name the town for him. Founder and future mayor Ebenezer Noyes wanted to name the town Essex but was voted down. It is unclear if William B. Mattoon helped attract settlers and merchants as the town's founders had hoped he would. However, he never lived in the city bearing his name. Mattoon left after completion of the TH&A and was last in the area to attend the funeral of Harrison Messer, who had been his superintendent during construction of the TH&A. (Courtesy of Mattoon Public Library.)

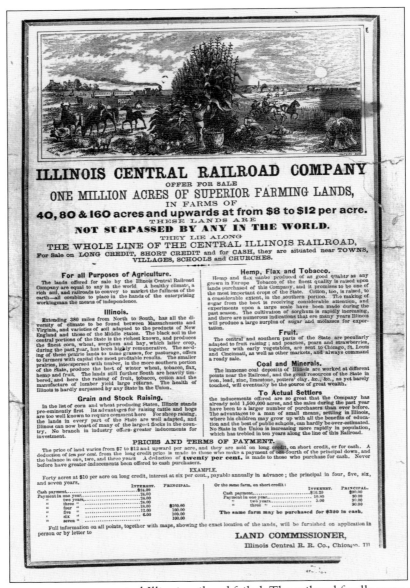

Several attempts to create a central Illinois railroad failed. The railroad finally came to fruition after Illinois senator Stephen A. Douglas sponsored a bill adopted by the senate on May 3, 1850, granting public lands for a railroad right-of-way. The House approved the bill on September 17, and Pres. Millard Fillmore signed it three days later. The Illinois General Assembly approved a charter for the Illinois Central Railroad (IC) that Gov. Augustus C. French signed into law on February 10, 1851. There were not enough men living in Illinois in the 1850s to build the IC. Some laborers were drawn from Ohio, Kentucky, New York, and New England, but most of the estimated 100,000 laborers who worked at one time or another on building the railroad came from overseas, most often Poland, Ireland, and Germany. They battled wet weather, disease, the danger of severe injury or death, alcohol-fueled fights, and ethnic conflicts. After the railroad was completed, many workers remained in Illinois to establish farms and businesses. (Courtesy of Mattoon Public Library.)

Before rails could be laid, land had to be surveyed and then graded. Preparation work for the IC through Coles County began on June 25, 1853, and was finished on November 29. The contractors performing this work then sold their equipment to the company doing preparation work for the TH&A. Railroad maintenance workers are shown in an undated photograph. (Courtesy of Mattoon Public Library.)

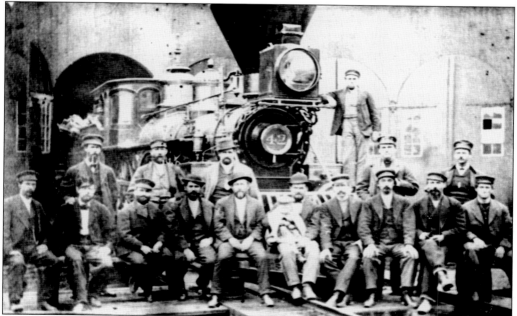

The Indianapolis and St. Louis Railroad (I&StL) agreed on December 20, 1869, to spend at least $100,000 to build locomotive and car shops on 30 acres in the northeast quadrant of Mattoon. The city agreed to provide the land and spend $5,000 for a reservoir to provide water. The shops opened in December 1871. Mattoon shop workers are shown in a photograph taken in the 1870s. (Courtesy of Mattoon Public Library.)

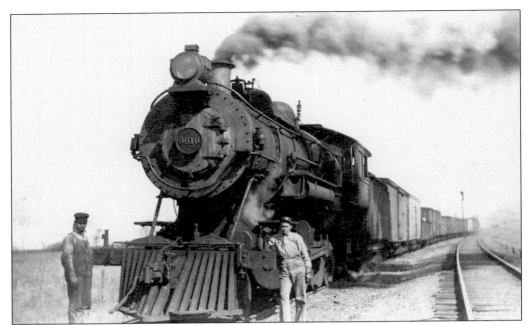

Early Illinois settlers stayed near rivers and streams, but the coming of railroads helped open the interior of the state. No longer would freight have to be shipped to eastern markets down the Mississippi River through New Orleans. In a scene typical of the early 20th century, the engine crew of a freight train poses at an unidentified location. (Courtesy of Mattoon Public Library.)

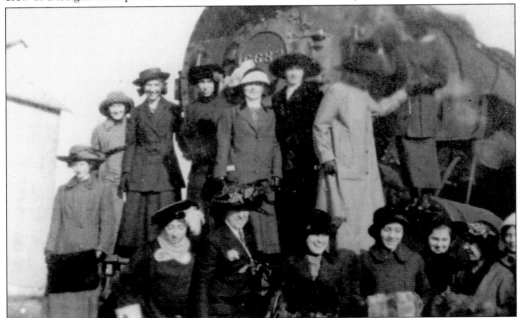

Emma Freeman was a Charleston nurse who gained fame for her work during a 1918 influenza epidemic. She was also a traveler. Freeman and several friends are shown on the nose of a steam locomotive in Charleston in 1913 before embarking on another journey. (Courtesy of Nancy Easter-Shick collection.)

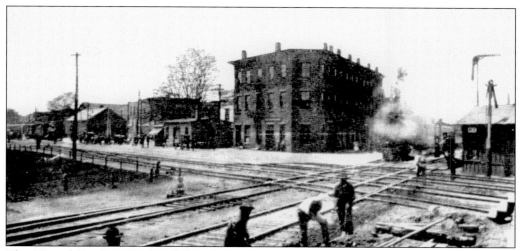

The IC and Big Four Railroad shared a union station on the first floor of the Essex House Hotel and restaurant in Mattoon. Construction began in 1857, and the hotel opened two years later. Located at the southwest corner of the intersection of the two railroads, the building was demolished to make way for a Railway Express Agency building that opened in 1918. (Courtesy of Mark Camp collection.)

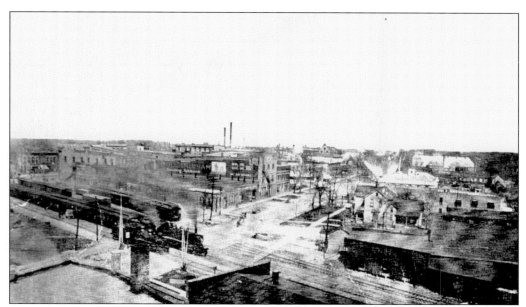

By 1900, Mattoon was a thriving city of 10,000. The railroads and agriculture were the city's early economic mainstays, and merchants and small industries were established to support them. Mattoon was also known for wide streets that were conducive to street fairs. A southbound IC train is shown crossing Charleston Avenue in an early-20th-century view looking eastward. (Courtesy of Mattoon Public Library.)

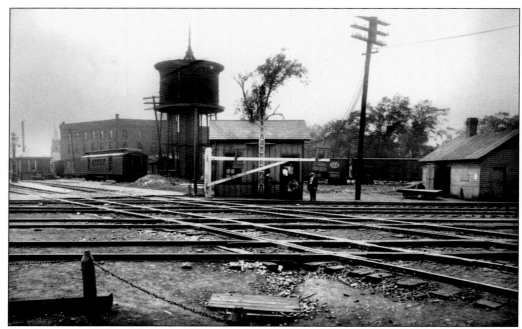

The crossing of the TH&A and IC was known as MX, a telegraph term for Mattoon crossing. It was situated across from the present-day Railway Express Agency building north of Broadway Avenue and west of the Canadian National Railway (CN) tracks. A gate guarded the crossing. The lower left tracks belonged to the IC. (Courtesy of Coles County Historical Society.)

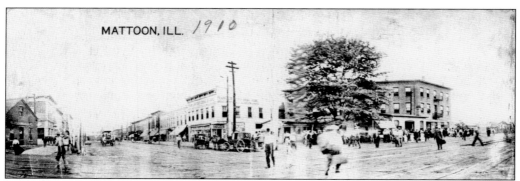

Broadway Avenue was the center of Mattoon in 1910, when this photograph was taken. The view looks westward from just east of the IC tracks. The three-story building at the far right is the Essex House Hotel, which also housed Mattoon Union Station. The building at the far left was the express depot. The streetcar track is in the middle of Broadway Avenue. (Courtesy of Mattoon Public Library.)

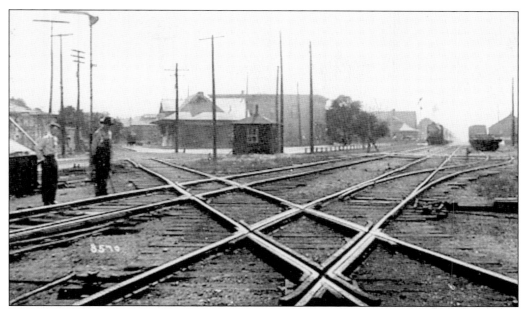

The Big Four Railroad and Clover Leaf Route crossed in Charleston between Fifth and Sixth Streets. In this 1910 view looking southwestward, the Clover Leaf Route depot is visible in the background while an eastbound Big Four Railroad train is either approaching the crossing or stopped at the passenger station. The track branching off at right leads to the Big Four Railroad freight station. (Courtesy of Coles County Historical Society.)

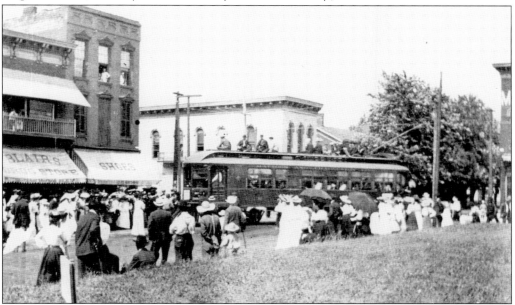

The Central Illinois Traction Company (CITC) interurban line entered Charleston on Monroe Avenue near Division Street and ended at Seventh Street on the square where there was a wye to turn cars. A carbarn was located at Third Street and Monroe Street, while the ticket office was in the 500 block of Monroe Street. A car is shown turning southward onto Seventh Street on the square. (Courtesy of Nancy Easter-Shick collection.)

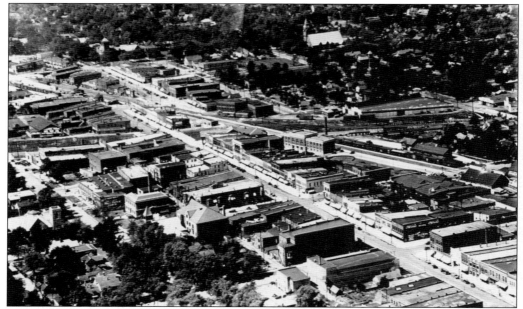

The railroads divided Mattoon into quadrants of relatively equal size. In this 1920s photograph looking northwestward, the New York Central System (NYC) station is in the center while the NYC freight station is across from the passenger station. The IC tracks are belowground beyond the smokestack just beyond the NYC station. The street bisecting from right to left is Broadway Avenue. (Courtesy of Mattoon Public Library.)

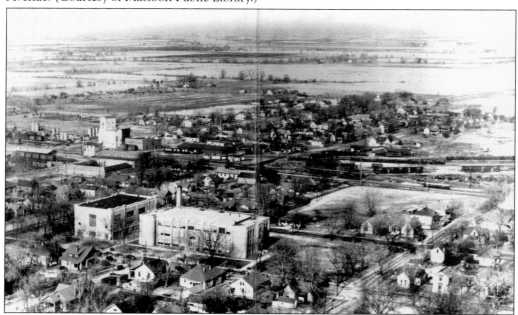

The NYC and Nickel Plate Road (NKP) passed through the north side of Charleston. In this 1939 view looking northwestward, Charleston High School is in the lower center of the photograph. The tower controlling the NYC-NKP crossing is just below the grain elevator at left. The NKP freight station is to the left of the tower. (Courtesy of Nancy Easter-Shick collection.)

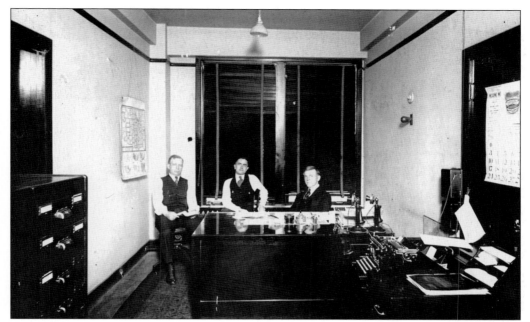

Passenger stations were places for the public to buy tickets and board trains, but upper floors of the IC and NYC passenger stations in Mattoon held offices. Working largely out of sight of the public, the employees in these offices conducted the paperwork associated with moving freight and passengers. This photograph was taken in November 1918. (Courtesy of Mattoon Public Library.)

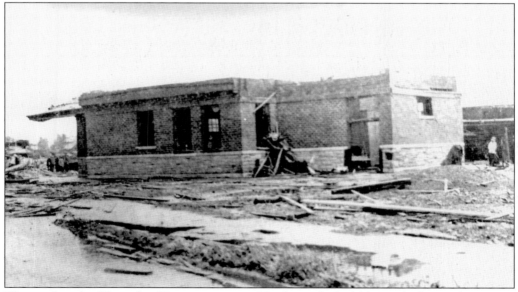

This is what the Clover Leaf Route station in Charleston looked like in the late 19th century. The premier passenger train in that era was the *St. Louis Express*, which made the trip from Toledo, Ohio, to St. Louis in less than 24 hours and carried Pullman palace coaches. A May 1917 tornado damaged the Clover Leaf Route passenger station by taking off the roof. (Courtesy of Nancy Easter-Shick collection.)

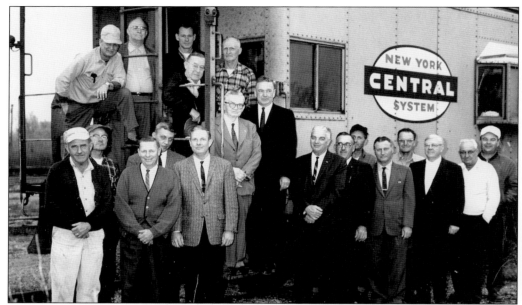

NYC car department workers in Mattoon are shown on November 15, 1967. Identified in the photograph are John Kendell, Howard Crum, John Dunn, John Tuttrow, Wendel Fiscus, Robert Thompson, Glenn Hite, Marion Buchanan, Andrew Welton, Foster Goodwin, Walter Young, Warren Jones, Joe Mathews, James Buckley, Harold Newlin, John McGee, Roland Thode, and Leo Brandenberg. (Courtesy of Glenn Hite collection.)

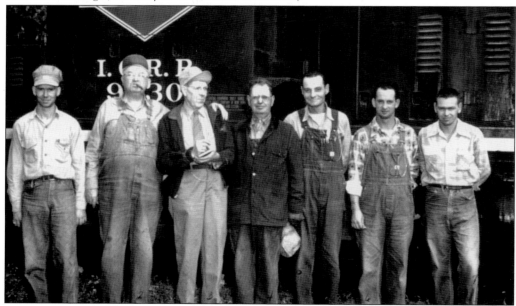

This Mattoon-based IC crew gathered at New Harmony, Indiana, for a portrait upon the completion of the last trip for conductor H. T. Harper on October 31, 1951. They are, from left to right, H. D. Burke (fireman), A. M. O'Neal (engineer), Harper, C. W. Miller (flagman), H. C. Snodgrass (brakeman), D. W. French (head brakeman), and John Cox (operator at New Harmomy). (Courtesy of Thomas French collection.)

Two

ELECTRIC RAILWAY
OPERATIONS

E. A. Potter was a Chicago businessman who came to Mattoon in 1901 with a grand vision. He purchased the Mattoon Gas Light and Coke Company and organized the Mattoon City Railway, which on June 3, 1902, received a franchise for a streetcar line. That same year Potter incorporated CITC, which obtained a streetcar franchise in Charleston and began acquiring land for a right-of-way between Mattoon and Charleston.

Potter envisioned his interurban railway as part of a network of electric railways forming an Indianapolis–St. Louis artery. He reportedly wanted to build routes to Paris, Shelbyville, Decatur, and Champaign. Potter told a Champaign County newspaper in April 1905 that CITC was certain to build that year between Mattoon and Champaign. But CITC only built between Mattoon and Charleston.

Construction began in 1903, and the company acquired Mattoon Heat, Light and Power Company, which had an electric generating plant. The first interurban car between Mattoon and Charleston ran on June 5, 1904. The company's five cars operated 16 daily roundtrips between 5:30 a.m. and 11:30 p.m. Streetcar service in Mattoon began four days later.

A Charleston streetcar line on Sixth Street opened in 1911, but not without controversy. A Charleston newspaper editor quipped in 1910 that there was no need for the service because people rode early morning bread wagons for free. "The reptilian trolley would undertake to charge a nickel. Ye Gods and little fishes! The great American freemen would not brook such an invasion of their sacred rights."

Having expanded its utility business in Mattoon and Charleston, CITC in 1910 renamed itself Central Illinois Public Service Company (CIPS). Two years later CIPS became a subsidiary of Middle West Utilities Company, which ultimately owned 60 Illinois utility companies and five electric railway systems serving nine communities. CIPS moved its headquarters from Mattoon to Springfield in 1921.

The utility business continued to thrive, but the railways did not. Buffeted by competition from private automobiles and buses, CIPS curtailed railway service. Buses replaced the Mattoon–Charleston interurban operation on May 20, 1928. Streetcar service in both cities ended about the same time.

The Mattoon City Railway operated a single-track route between Thirty-third Street and Sixth Street. Cars traveled on Prairie Avenue, Nineteenth Street, and Broadway Avenue. There were spur lines from Broadway Avenue to Charleston Avenue on Sixteenth Street, and from Broadway Avenue onto Fourteenth Street to the company's carbarn adjacent to the electric generating plant. These girls are waiting for a car on Prairie Avenue. (Courtesy of Mattoon Public Library.)

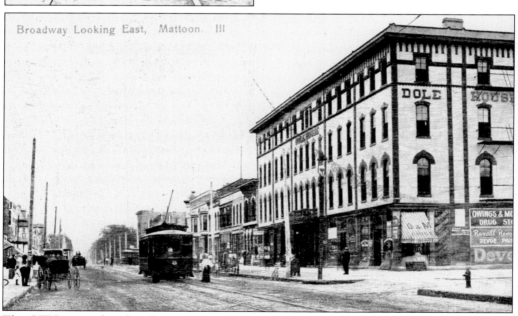

Broadway Looking East, Mattoon. Ill.

The CITC interurban line between Mattoon and Charleston paralleled the Big Four Railroad but still did a thriving passenger and freight business. The interurban fare was 35¢. The interurban operations were said to be profitable, but the Mattoon streetcar operation lost money. A Mattoon city car is shown on Broadway Avenue in a view looking east. (Courtesy of Mattoon Public Library.)

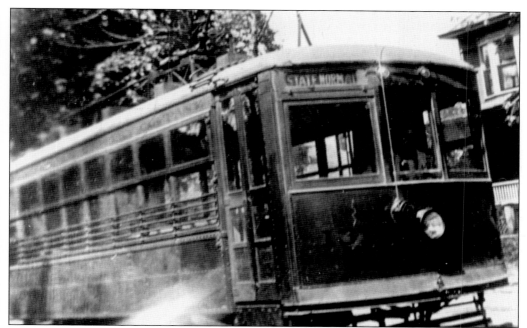

CITC opened a line in Charleston in 1911 on Sixth Street between Lincoln Avenue and Railroad Avenue and thence west to the Coles County Fairgrounds. In 1919, the company ordered 10 four-wheel Birney safety streetcars for its five streetcar systems. Three cars were assigned to Mattoon and one to Charleston. Car No. 131 is shown in Charleston. (Courtesy of Nancy Easter-Shick collection.)

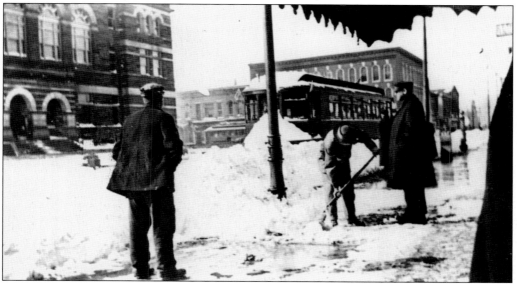

Built to lighter standards than steam railroads, interurban railways were cheaper to operate and provided cleaner and more comfortable travel. Their lower fares combined with frequent service provided many Americans with a degree of mobility they had never had. Unlike steam railroads, interurban railway cars would stop at any crossroad. A car is shown on Monroe Avenue in Charleston on the square. (Courtesy of Nancy Easter-Shick collection.)

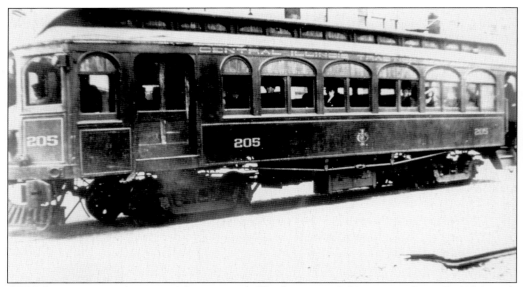

CITC began service between Mattoon and Charleston at 8:00 a.m. on June 5, 1904, with 30 aboard the inaugural run. More than 1,000 rode that day. Trips were scheduled to take 30 minutes, leaving Charleston on the hour and Mattoon on the half hour. The company began bus service between Charleston and Paris on March 13, 1927, in an effort to boost patronage. (Courtesy of Nancy Easter-Shick collection.)

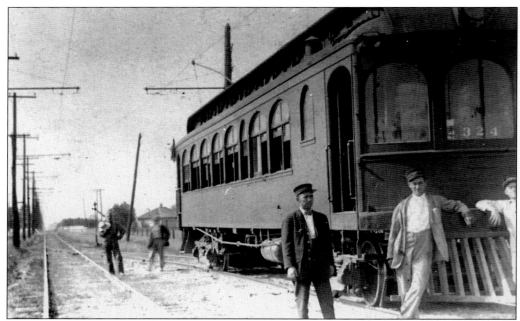

In its final years, wags called the Charleston streetcar line the "Back and Forth and Empty." Patronage was light despite the line serving Eastern Illinois State Normal School, the Big Four Railroad and Clover Leaf Route stations, and the square. The city council in 1928 allowed the line to end after 17 years of service. The crew poses with a car near Railroad Avenue. (Courtesy of Nancy Easter-Shick collection.)

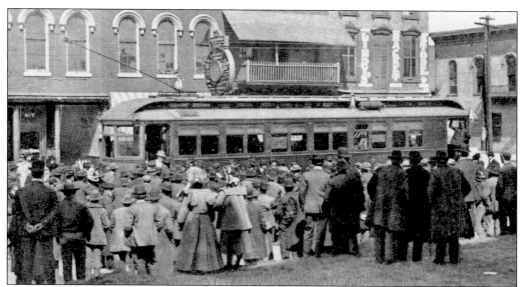

Patronage of CITC cars between Mattoon and Charleston was particularly high during the Coles County Fair and the chautauqua performances held at the fairgrounds through 1918. Another attraction was Interurban Park, located at the site of today's Charleston Country Club. The park featured swimming, boating, amusement rides, baseball, balloon rides, a zoo, concerts, dances, and July 4 fireworks exhibitions. A 38-day revival conducted by famed evangelist William Ashley (Billy) Sunday in March and April 1908 in Charleston also attracted thousands, many of whom came on the interurban. In the photograph above, the car carrying Sunday is shown arriving on the Charleston Square amid a throng of onlookers. Sunday is shown alighting from the car in the photograph below. (Above, courtesy of Coles County Historical Society; below, courtesy of Nancy Easter-Shick collection.)

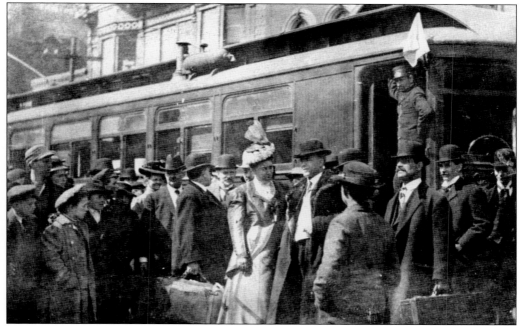

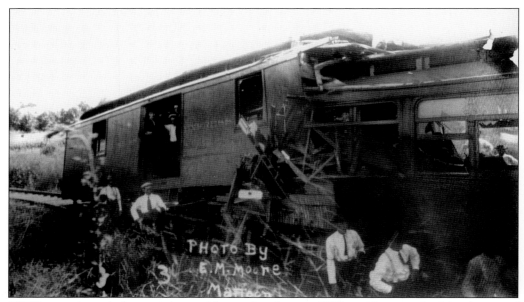

CITC experienced three major accidents. An August 1905 accident resulted in dozens of injuries. A motorman was killed, and a passenger lost both legs when two cars collided two miles east of Mattoon on September 2, 1906. Shown is the aftermath of an August 30, 1907, collision near Cossel Creek on a curve two miles west of Charleston that left 18 dead and 60 injured. An eastbound special carrying 100 passengers to the Coles County Fair struck a westbound express car. Both were traveling at high speed, and there were no warning whistles or brake applications before the collision. Some survivors walked to Charleston to summon help. CITC blamed the motorman of the express car. To protect itself from lawsuits, CITC declared bankruptcy. (Above, courtesy of Coles County Historical Society; below, courtesy of Nancy Easter-Shick collection.)

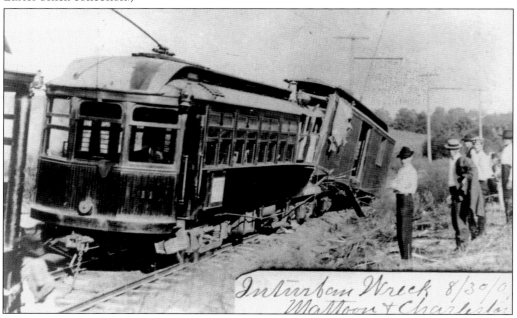

Three

ILLINOIS CENTRAL RAILROAD

IC was the country's longest north-south railroad and was known for conservative management practices that sometimes yielded some striking contrasts. Steam locomotives lingered in freight service through 1960, yet IC was among the first railroads to buy diesels for passenger service. If its diesel freight locomotives appeared drab in their black dress, the IC's passenger locomotives wore a flashy orange and brown livery.

IC began shaking its stodgy ways in the late 1960s with several innovative freight-marketing programs and the hiring of Alan Boyd as president. A career government regulator, Boyd called his lack of railroad experience an advantage because it would enable him to challenge long-standing railroad practices and ideologies.

The 1972 merger of the IC and Gulf, Mobile and Ohio Railroad to form the Illinois Central Gulf Railroad (ICG) did not bring about the expected financial benefits. Labor protection provisions curtailed productivity gains, and traffic growth and earnings were disappointingly small. With its parent company, Illinois Central Industries (ICI), unable to sell the ICG to another railroad, management launched a line sale program. Between 1985 and 1987, ICG sold five packages of routes to regional and short-line operators and abandoned hundreds of miles of branch lines.

After slimming to a 2,900-mile system, ICG stock was transferred to ICI shareholders and railroad employees on January 1, 1989. The IC name returned, and locomotives were repainted black with white lettering. Just over two months later, the IC was acquired by the Prospect Group, owner of MidSouth Rail Corporation, an operator of 481 miles of former ICG track.

New IC president Edward Moyers sought more economies by closing or shrinking yards and converting the double-track Chicago–New Orleans main line to single track with centralized traffic control. The single-tracking conversion began in May 1989 and ended on August 28, 1991.

During the 1990s the IC was one of the nation's most efficient carriers, but its relatively small size made it ripe for acquisition by another railroad. CN bought the IC in 1999.

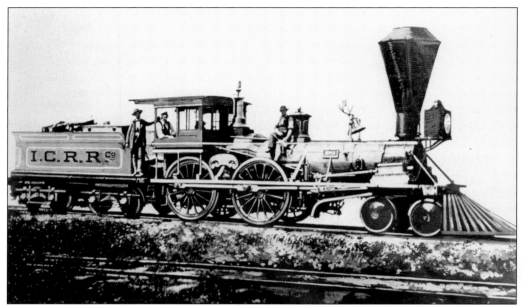

Locomotives of the 1850s were small and lightweight compared with their later brethren, which were known for size and power. Although IC tracklayers reached Mattoon in June 1855, the planned route between Mattoon and Centralia was swampy and poorly drained. Track laying was not completed until September 27, 1856, with the pounding of the last spike near Mason. (Courtesy of Mattoon Public Library.)

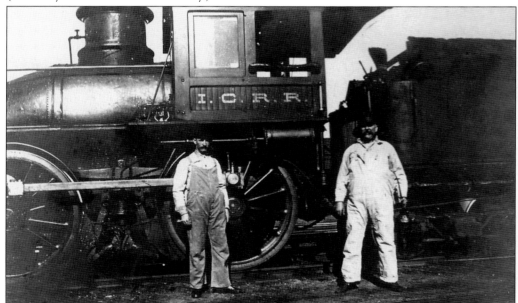

Freight and passenger service usually began shortly after a segment of the IC was completed. In its first two decades of operation, the IC operated four daily passenger trains through Mattoon. Trains were slow by modern standards. An express train, for example, left Chicago at 9:30 p.m, arrived in Mattoon at 4:43 a.m. the next day and reached Cairo at 3:15 p.m. (Courtesy of Mattoon Public Library.)

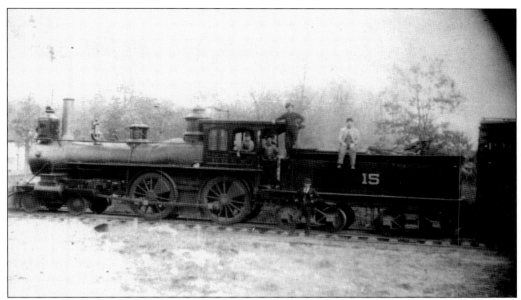

The Peoria, Decatur and Evansville Railway (PD&E) and many of its 28 separate predecessor companies were no strangers to financial problems and hardships. The PD&E yardmaster at Mattoon sometimes had to use oxen to switch cars at the freight house. PD&E locomotive No. 15 was a 4-4-0 type built by Brooks Locomotive Works in November 1880 and retired in November 1909. (Courtesy of Coles County Historical Society.)

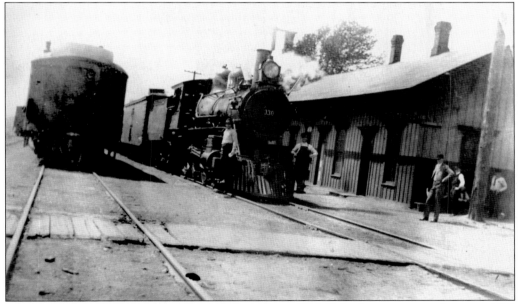

The Decatur, Mattoon and Southern Railway (later PD&E) built a passenger depot in 1878 on Twenty-first Street between Marshall Avenue and Lafayette Avenue. The station hosted six trains a day, including a pair that carried a parlor car, sleeper, and dining car. The IC shifted former PD&E passenger trains to Mattoon Union Station after acquiring the PD&E in 1900. (Courtesy of Mattoon Public Library.)

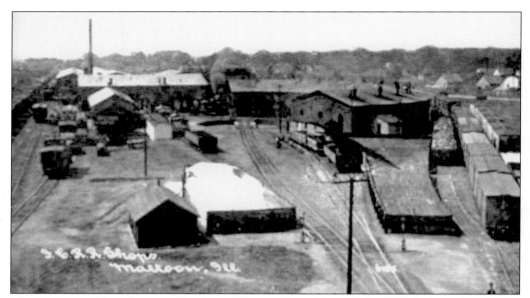

Mattoon was midway between Peoria and Evansville and hosted the PD&E shops. Forerunner Decatur, Mattoon and Southern Railroad established the shops complex at Twenty-seventh Street near Broadway and Charleston Avenues, opening it by July 1878. The PD&E expanded the complex in 1880 to include a 14-stall roundhouse, machine shop, boiler shop, blacksmith shop, reclaim shop, woodworking shop, and car repair shed. (Courtesy of Thomas French collection.)

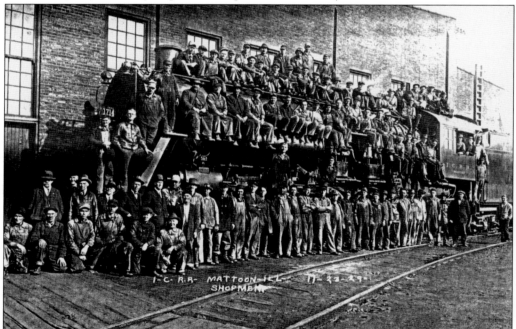

The PD&E shops in Mattoon employed between 500 to 600 workers around the dawn of the 20th century. Through 1950, at least half of the city's workforce was railroad related, either in direct employment by the IC or the NYC or in a supporting capacity. Some neighborhoods existed to serve railroad workers. (Courtesy of Coles County Historical Society.)

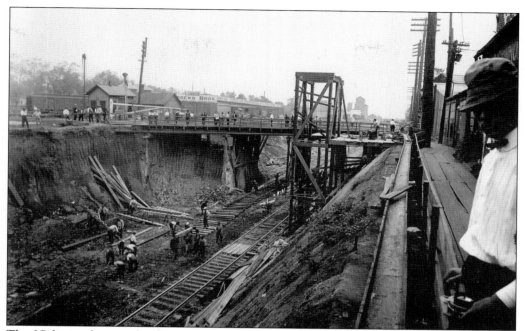

The IC lowered its tracks through Mattoon as it also did at Monee and Paxton. More than 1,500 people who had hoped to ride the first train through the subway on July 20, 1914, were turned away for lack of space. The photograph above looks northward from Broadway Avenue toward the temporary Big Four Railroad bridge over the IC. The gate at upper left guarded the former junction of the IC and Big Four Railroads. The view in the photograph below is southward and shows the temporary Broadway Avenue bridge. The building at the right end of the bridge is the American Railway Express Company office. The building near the edge of the excavation is an IC baggage office. Both photographs were taken in 1914. (Courtesy of Mattoon Public Library.)

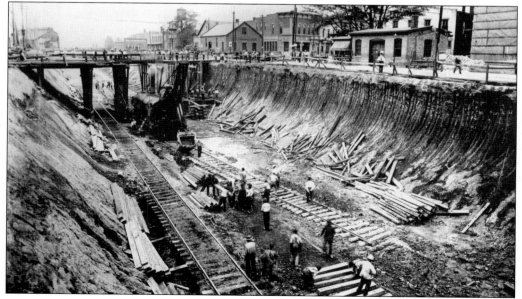

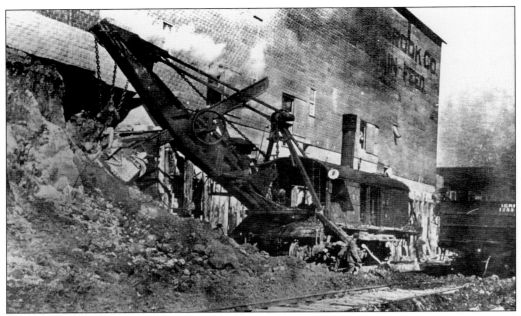

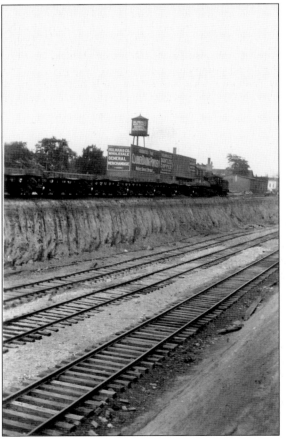

The steam shovel in the photograph above did heavy duty during excavation of the "million-dollar trench" by Lynch Construction Company. The moniker reflected the $1 million project cost. Excavation began on May 16, 1914. Before completion of the project on March 6, 1916, workers would excavate 260,000 cubic yards of earth and build six bridges. Much of the excavated material was removed in freight cars, shown in the photograph at left, and used to reduce a grade on Magnet Hill south of the city. By lowering its tracks through Mattoon, the IC avoided a busy junction with the Big Four Railroad and spared Mattoon some major traffic problems after the rise in popularity of the automobile. The only street that crosses the IC at grade in Mattoon is Marshall Avenue. (Courtesy of Mattoon Public Library.)

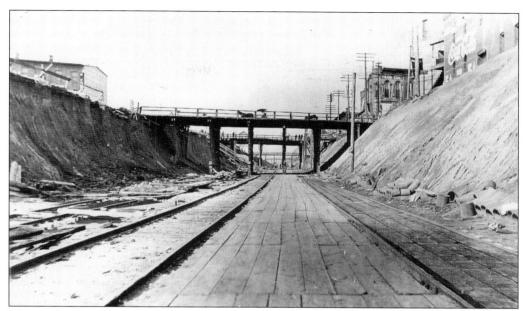

The new IC tracks are in place in the subway, as Mattoon residents called it, but much work remains to be done to finish the project. In the photograph above, taken in 1914, the view from track level looks north toward the temporary Broadway Avenue bridge. The building in the upper left corner is the Essex House Hotel, which has had its eastern facade sheared off during construction of the subway. The Essex House, which also housed Mattoon Union Station, remained open until the IC and Big Four Railroad completed new passenger depots. In the photograph below, taken from the Broadway Avenue bridge, a stairway leads from the union station to the IC tracks below. (Above, courtesy of Mattoon Public Library; below, courtesy of Coles County Historical Society.)

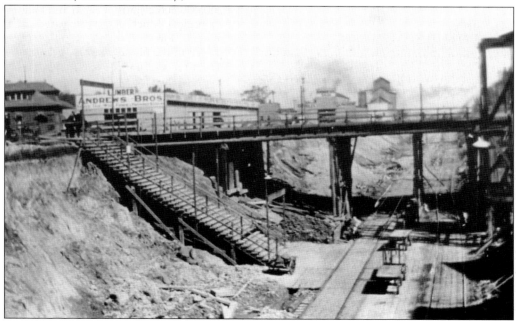

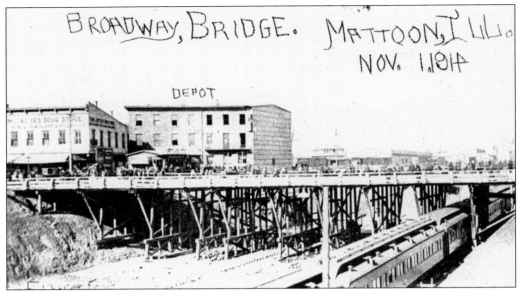

This interim wooden bridge carrying Broadway Avenue over the IC tracks gave way to a concrete bridge that stood until being replaced in 2002. All of the six bridges built over the IC as part of the subway project have since been replaced. Charleston Avenue was replaced in 1980, Dewitt Avenue in 1995, Richmond Avenue in 2001, and Champaign Avenue in 2005. (Courtesy of Mattoon Public Library.)

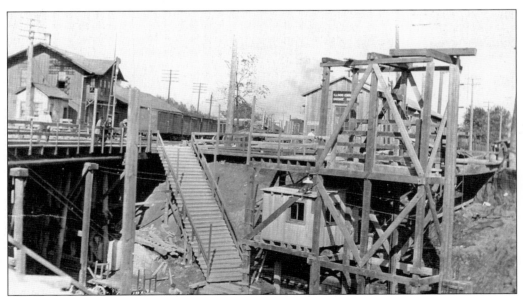

The framework of the freight elevator of the IC station is in place, and excavation has begun for building a retaining wall around the station site. That digging began in October 1916. At one point, walls of nearby buildings collapsed as a result of pile driving and wet weather. The building to the left is the Big Four Railroad freight station. (Courtesy of Mattoon Public Library.)

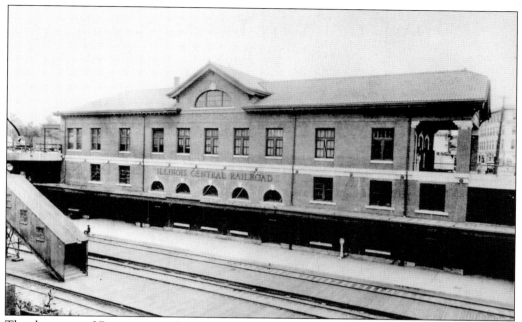

The three-story IC station was designed by Daniel F. McLaughlin and cost $130,000. It opened on January 21, 1918. The covered stairway at left enabled passengers to transfer directly to or from the Big Four Railroad platforms. Out of sight to the left is a power plant that served the passenger stations of both railroads. (Courtesy of Mattoon Public Library.)

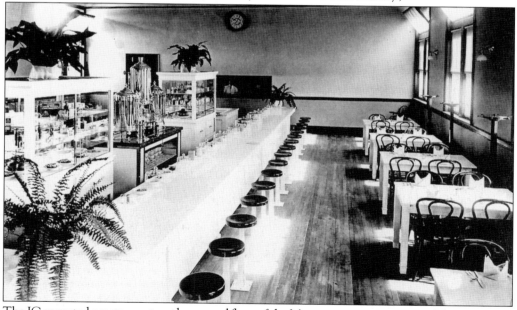

The IC operated a restaurant on the second floor of the Mattoon passenger station. The restaurant closed in the 1930s, probably as a cost-cutting move. During World War II, the United Service Organizations opened a lounge in the former restaurant on August 14, 1942. It is thought to have been the only USO facility south of Chicago catering to servicemen in transit. (Courtesy of Mattoon Public Library.)

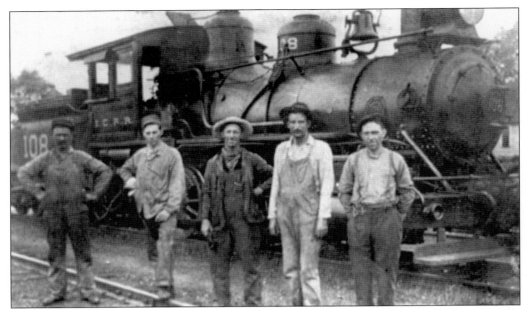

Although the IC began coordinating schedules with Southern railroads on February 26, 1860, thus creating a Chicago–New Orleans route, passengers had to transfer between trains by boat. The IC began ferrying through passenger cars across the Ohio River on December 24, 1873. A bridge over the river at Cairo opened on October 29, 1889. IC crewmembers are shown posing in an undated photograph. (Courtesy of Mattoon Public Library.)

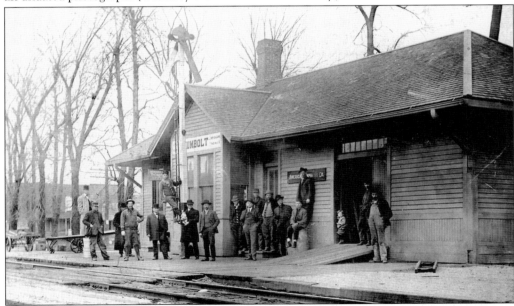

Originally known as Milton, the town of Humboldt was surveyed on November 12, 1858. The IC was the town's only railroad. The last passenger train to serve the Humboldt station was the northbound *Northern Express*. No. 26 still stopped here in early 1948 but had begun bypassing Humboldt by 1952. Southbound passenger trains had ceased stopping at Humboldt before the mid-1940s. (Courtesy of Mark Camp collection.)

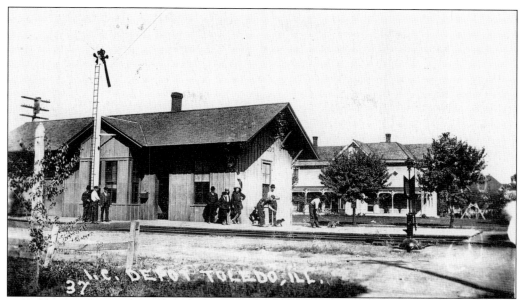

In the early 1900s, the IC operated three pairs of passenger trains between Mattoon and Evansville, Indiana. One pair, the *Chicago Limited* and *Nashville Limited*, carried through cars between Chicago and Nashville, Tennessee. The last pair of passenger trains became mixed trains on March 16, 1939. Nos. 235/236 ceased carrying passengers on August 13, 1939, which ended rail passenger service to Toledo. (Courtesy of Mark Camp collection.)

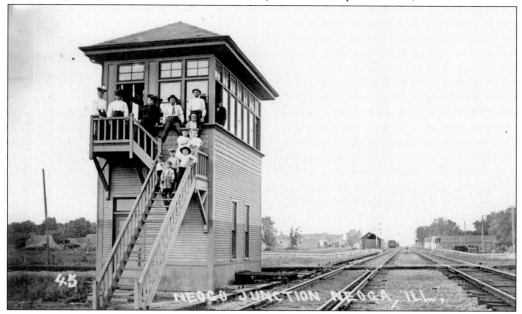

In April 1922, the IC named a Chicago–Mattoon passenger train the *Mattoon Passenger*. Its northbound counterpart was the *Chicago Passenger*, which originated in Cairo. Both trains carried dining and parlor cars. The *Mattoon Passenger* last operated in May 1931. Shown above is the tower that guarded the crossing of the IC with the NKP at Neoga. (Courtesy of Mark Camp collection.)

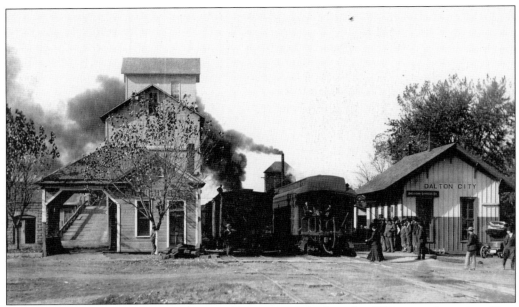

Passenger service on the IC northwest of Mattoon peaked in the 1920s at eight trains. Four Mattoon–Decatur trains were assigned motor cars in 1924 and discontinued on May 24, 1931. Peoria–Mattoon Nos. 233 and 234 became mixed trains on March 26, 1939, and ceased carrying passengers in March 1940. A passenger train is shown at Dalton City in an undated photograph. (Courtesy of Mark Camp collection.)

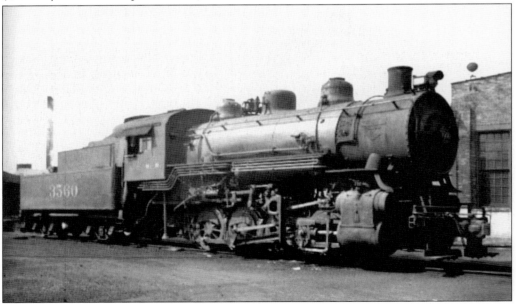

Between 1921 and 1929, Baldwin Locomotive Works and Lima Locomotive Works built seventy 3500-class switcher type 0-8-0 locomotives for the IC. Through 1956, two of these locomotives performed switching duties in Mattoon. The last of these engines worked through April 1960, although they were gone from Mattoon by then. No. 3560 is shown at the Mattoon shops in an undated photograph. (Courtesy of Thomas French collection.)

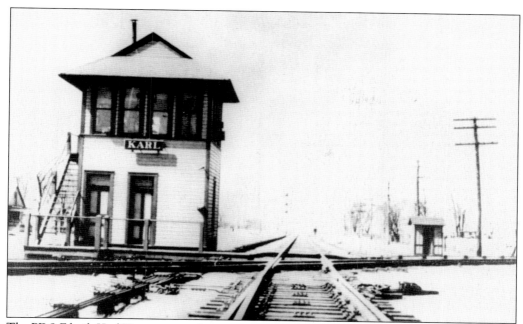

The PD&E built Karl Tower to guard its crossing with the Big Four Railroad at Broadway Avenue and Thirty-second Street in Mattoon. The cross-gabled roof was typical of PD&E structures built in the 1890s. The PD&E also had a tower near Marshall Avenue at the crossing of the IC. The view above is west on the Big Four Railroad. (Courtesy of Glenn Hite collection.)

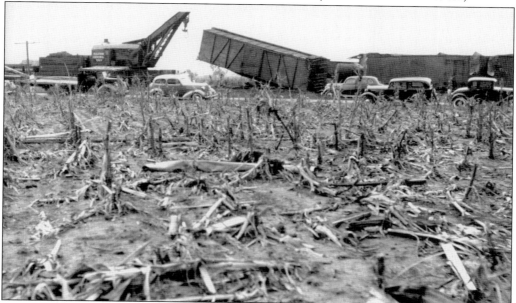

A tornado derailed IC freight train No. 272 on July 12, 1938, at about 7:00 p.m. near Allenville on the Mattoon–Decatur line. Eleven cars were blown off the tracks and 200 feet of track damaged. The crew, which was not injured, included engineer T. M. Thomas, fireman O. L. French, conductor H. T. Harper, and brakemen C. C. Crist and C. W. Miller. (Courtesy of Thomas French collection.)

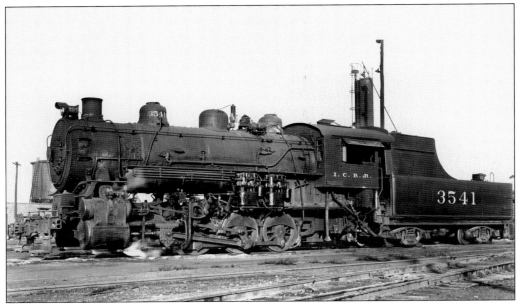

The IC had an efficient steam locomotive fleet and easy access to low-cost coal. In early 1950, IC president Wayne A. Johnston said the railroad "will not dieselize its freight service for a long time, if ever." Yet the steam era ended in 1960. Steam's demise was seven years away as 0-8-0 No. 3541 reposed at the Mattoon shops in November 1953. (Courtesy of Jay Williams collection.)

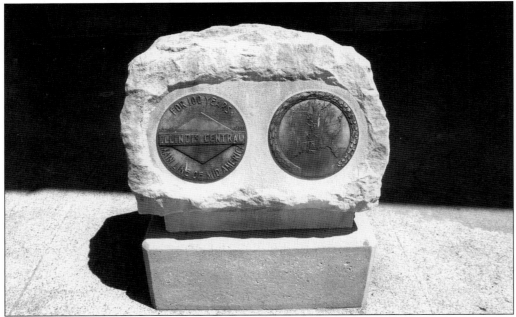

To celebrate its centennial in 1951, the IC had medallions struck and mounted on stone blocks at more than 100 locations, usually in front of passenger stations. The Mattoon monument is located near the entrance to the former IC passenger station on Broadway Avenue. From 708 miles in 1856, the IC peaked at more than 5,000 miles in the early 1900s. (Photograph by Craig Sanders.)

The IC tested diesel locomotives on freight trains between Mattoon and Evansville, Indiana, in 1952. Satisfied with the cost savings the diesels achieved, the IC purchased a fleet of GP7 and GP9 diesels from the Electro-Motive Division of General Motors Corporation. In a scene typical on the IC in the 1950s and early 1960s, a pair of GP9 locomotives hauls a freight train at Maroa. (Photograph by James McMullen.)

Rather than order new cabooses, the IC built 100 all-steel "crummies" in its own shops and numbered them 9900–9990. For years, IC cabooses had marker lights, but during the 1960s the company switched to reflective metal flags. Wooden cabooses continued in service through the early 1970s. The caboose shown here is on a northbound coal train at Effingham on July 7, 1968. (Photograph by James McMullen.)

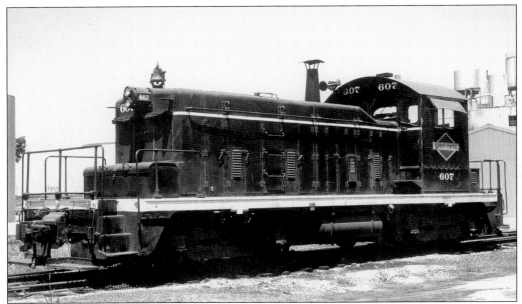

A Chicago law designed to minimize locomotive smoke led the IC in 1928 to purchase its first diesel locomotives for switching duties. No. 607, an SW1 built by the Electro-Motive Division of General Motors Corporation, was one of 18 locomotives in its class built between 1940 and 1951. It remained in service on the IC and, later, Illinois Central Gulf Railroad, through 1976. (Photograph by James McMullen.)

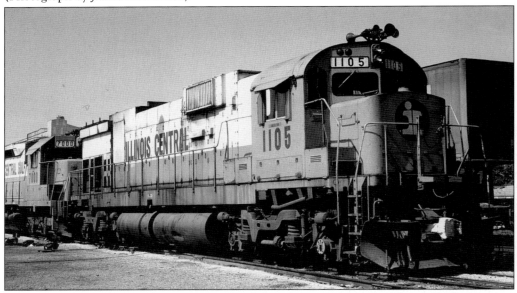

The IC purchased six Alco Century C636 locomotives in 1968. The 3,600-horsepower locomotives were the IC's most powerful diesels and rode on high-adhesion six-axle trucks. Yet they were an oddity on a railroad where the Electro-Motive Division of General Motors Corporation had built most of the locomotives. Initially assigned to Chicago–New Orleans freight trains, the Alcos were reassigned to hauling coal trains in Kentucky. (Photograph by James McMullen.)

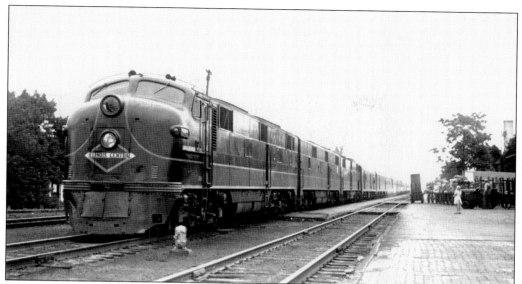

The IC inaugurated the *City of New Orleans* on April 27, 1947, on a 16-hour dawn-to-dusk schedule between Chicago and New Orleans. Nos. 1 and 2 averaged 80 miles per hour between Champaign and Mattoon, and Mattoon and Effingham, routinely hitting 100 miles per hour. The southbound *City* is at Effingham on June 29, 1951. (Photograph by Otto Perry, courtesy of Denver Public Library, Western History Collection, OP 12364.)

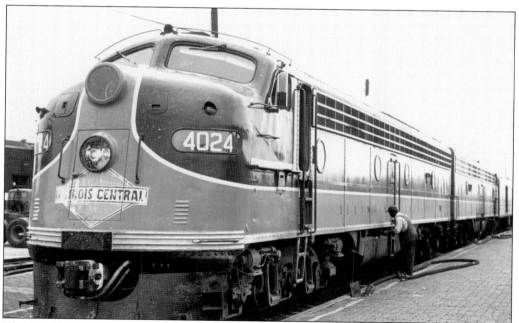

The first IC streamlined passenger train to serve Mattoon was the *City of Miami*, which debuted on December 18, 1940. IC passenger locomotives featured a livery of chocolate brown and orange with yellow striping and the green diamond herald on the nose. E8A No. 4024 pauses for servicing at Centralia at the head of the Chicago-bound *Creole* on July 28, 1966. (Photograph by James McMullen.)

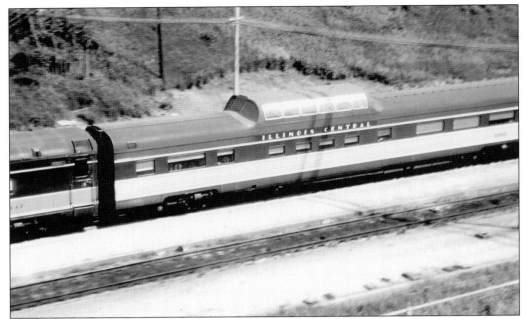

The IC purchased six used dome coaches from the Missouri Pacific Railroad in June 1967 and assigned them to the *City of Miami* and *City of New Orleans*. The dome section got hot in the summer, so IC workers painted over or replaced the top and forward windows with steel plates. The northbound *City of Miami* is shown arriving in Mattoon in 1969. (Photograph by Richard Record Jr.)

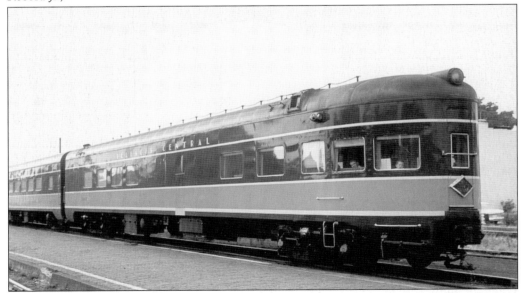

The round-ended observation cars associated with streamlined passenger trains typically were lounge cars. Three IC passenger trains serving Mattoon featured such cars: the *City of Miami*, the *City of New Orleans*, and the *Panama Limited*. These cars were removed from service on January 1, 1969. Shown is the observation car of the southbound *City of New Orleans* on July 28, 1966. (Photograph by James McMullen.)

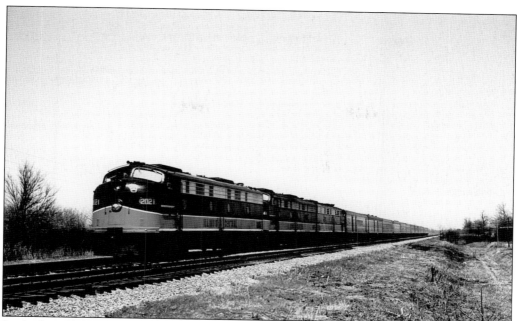

In the late 1960s, the IC modified its passenger locomotive livery. The railroad name on the locomotive flanks was converted to large Gothic lettering, and the amount of orange on the nose was reduced. The Amtrak era is drawing near as E8A No. 2021 leads the southbound *City of New Orleans* at Aetna, just south of Mattoon, on April 11, 1971. (Photograph by James McMullen.)

Thousands of children rode IC passenger trains on school outings. In Mattoon, children often rode the *City of New Orleans* to Effingham. Scheduled to leave Mattoon at 10:34 a.m., the trip was 27 miles and took 21 minutes. For some children, it would be their first and only train trip. IC ticket agents often gave the children this souvenir badge to commemorate their journey.

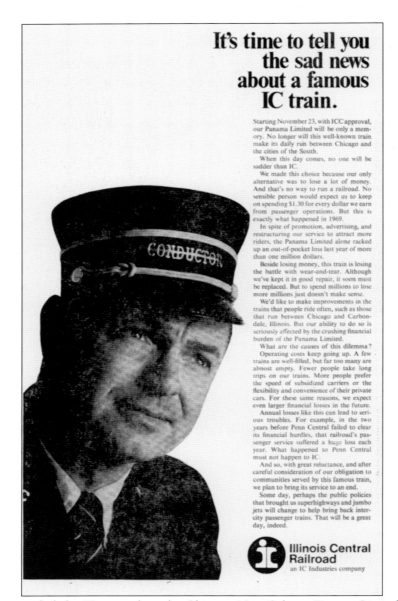

It's time to tell you the sad news about a famous IC train.

Starting November 23, with ICC approval, our Panama Limited will be only a memory. No longer will this well-known train make its daily run between Chicago and the cities of the South.

When this day comes, no one will be sadder than IC.

We made this choice because our only alternative was to lose a lot of money. And that's no way to run a railroad. No sensible person would expect us to keep on spending $1.30 for every dollar we earn from passenger operations. But this is exactly what happened in 1969.

In spite of promotion, advertising, and restructuring our service to attract more riders, the Panama Limited alone racked up an out-of-pocket loss last year of more than one million dollars.

Beside losing money, this train is losing the battle with wear-and-tear. Although we've kept it in good repair, it soon must be replaced. But to spend millions to lose more millions just doesn't make sense.

We'd like to make improvements in the trains that people ride often, such as those that run between Chicago and Carbondale, Illinois. But our ability to do so is seriously affected by the crushing financial burden of the Panama Limited.

What are the causes of this dilemma? Operating costs keep going up. A few trains are well-filled, but far too many are almost empty. Fewer people take long trips on our trains. More people prefer the speed of subsidized carriers or the flexibility and convenience of their private cars. For these same reasons, we expect even larger financial losses in the future.

Annual losses like this can lead to serious troubles. For example, in the two years before Penn Central failed to clear its financial hurdles, that railroad's passenger service suffered a huge loss each year. What happened to Penn Central must not happen to IC.

And so, with great reluctance, and after careful consideration of our obligation to communities served by this famous train, we plan to bring its service to an end.

Some day, perhaps the public policies that brought us superhighways and jumbo jets will change to help bring back inter-city passenger trains. That will be a great day, indeed.

Illinois Central Railroad
an IC Industries company

Nothing personified the IC more than the Chicago–New Orleans *Panama Limited*. Begun in February 1911, the *Panama Limited* became all Pullman in November 1916. Suspended on May 28, 1932, during the depths of the Great Depression, the *Panama Limited* returned on December 2, 1934, on a 20-hour schedule amid much fanfare. When streamlined on May 3, 1942, the *Panama Limited* introduced the orange and chocolate brown livery that became standard for all IC passenger trains by the 1950s. Assigned coaches on October 29, 1967, the *Panama Limited* was the nation's penultimate all-Pullman train. In early October 1970, the IC said it would end the *Panama Limited* on November 23, saying it lost $1 million in 1969. The IC placed this newspaper advertisement explaining why "with great reluctance and after careful consideration" it was pulling the plug. The Interstate Commerce Commission blocked the discontinuance, saying the Rail Passenger Service Act of 1970 left it for Amtrak to decide which trains would survive or die. The *Panama Limited* began its last runs as an IC train on April 30, 1971.

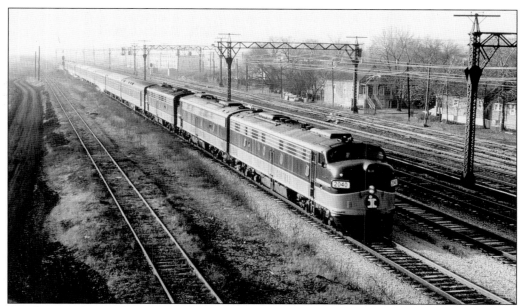

On the eve of Amtrak in April 1971, the IC operated 12 passenger trains through Mattoon, a level of service that had remained constant since 1951. Many who boarded in Mattoon were bound for Chicago for business or pleasure trips. The travel time was just over three hours. The *Panama Limited* is just minutes away from Chicago Central Station in December 1969. (Photograph by Dwight Long.)

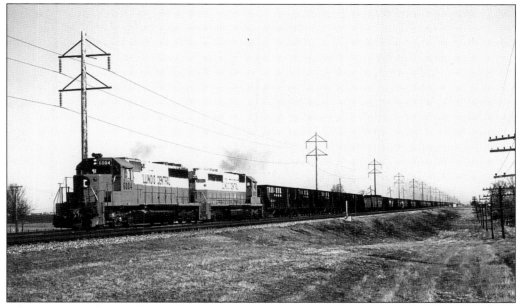

After assuming the presidency of the IC on May 2, 1966, William B. Johnson commented that the company's rolling stock "looked awfully plain." IC locomotives and freight cars soon were wearing a livery of burnt orange and white. A split-rail herald replaced the diamond logo the railroad had used for more than a century. A freight train exhibits the livery in July 1976. (Photograph by James McMullen.)

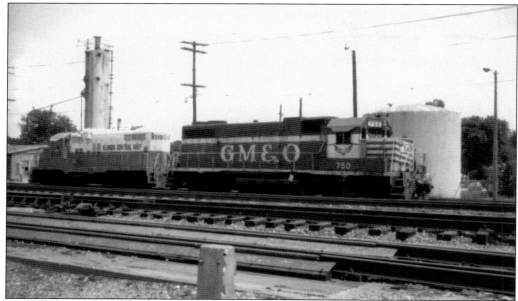

The IC began talking with the Gulf, Mobile and Ohio Railroad (GM&O) in 1962 about a merger, which was agreed upon in July 1968. It took several years to clear the regulatory hurdles before the ICG emerged on August 10, 1972. One immediate effect was that former GM&O locomotives began showing up along the former IC, including this one reposing in Mattoon. (Photograph by Leland Warren.)

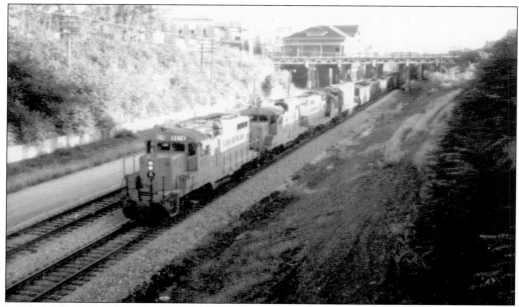

At its peak, the ICG served 13 states and stretched from Mobile and Montgomery, Alabama, to Sioux Falls, South Dakota; Albert Lea, Minnesota; and Madison, Wisconsin. ICG had 9,494 miles of track, of which 2,372 miles was former GM&O trackage. A northbound ICG manifest freight is shown leaving Mattoon in a view captured from near Richmond Avenue. (Photograph by Leland Warren.)

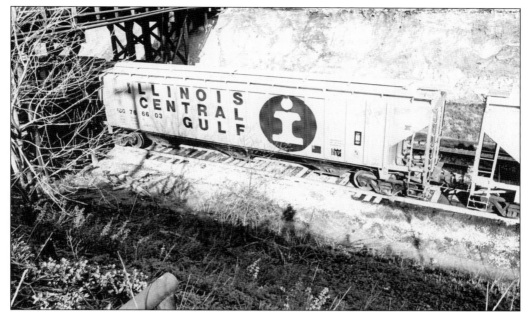

In 1967, IC marketing executive John W. Ingram originated the "rent-a-train" idea. Illinois corn, wheat, and oats volume shippers received an 86-car train for $1 million a year ($700,000 if the shipper supplied the cars) plus one and a half mills (a mill being one-tenth of a cent) per ton-mile for shipments to Gulf of Mexico ports. The rent-a-train concept received critical acclaim but suffered teething problems. The inaugural train derailed twice en route to Baton Rouge, Louisiana, and the covered hoppers did not stand up as well as hoped to the rigors of making a trip a week. Nonetheless the unit train idea soon caught on in the railroad industry. A southbound grain train passes beneath a rickety bridge at Magnet Hill south of Mattoon in April 1978 in the photograph above. The same train is shown in the photograph below. (Photographs by Craig Sanders.)

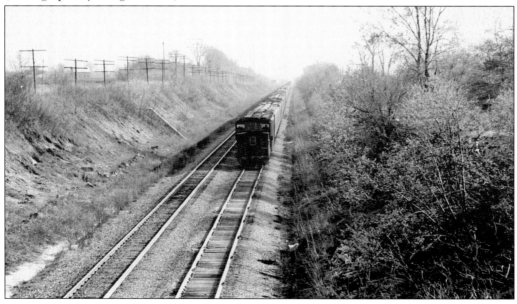

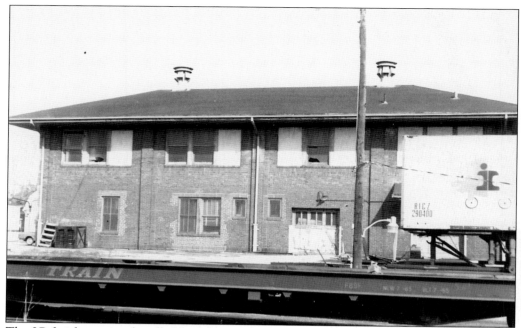

The IC freight station handled less-than-carload shipments. This business largely was lost to trucks and airfreight forwarders, and the building closed in 1969. Some freight continued to be transloaded, including newsprint for the Mattoon *Journal Gazette*. The last railroad-related use of the freight station was as a ramp for loading truck trailers onto flatcars. This operation lasted through 1981. (Courtesy of Mattoon Public Library.)

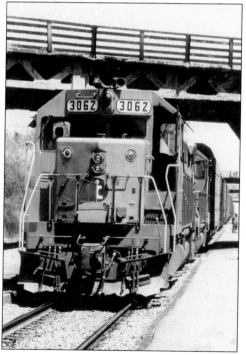

The IC had an automatic train stop system between Champaign and Centralia. A stopped train, such as this one in Mattoon, or a rail break triggered a red signal in the cab of nearby trains and automatically stopped a train if the engineer failed to turn a lever in response within seven seconds. The system was removed in 1991 in favor of block signals. (Photograph by Craig Sanders.)

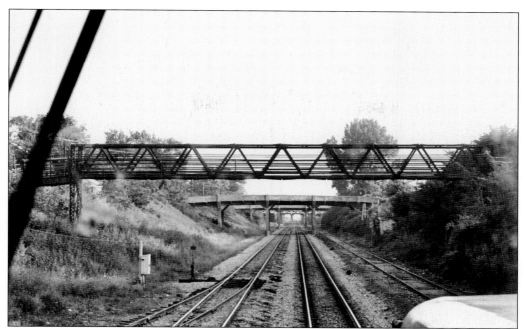

Generations of IC locomotive crewmembers have had this tunnel-like perspective of Mattoon. In the photograph above, taken on August 10, 1977, looking southward from a GP40 locomotive, the train is about to pass under the Shelby Avenue pedestrian bridge. In the distance are bridges carrying Champaign and Richmond Avenues, and the former NYC (then owned by Consolidated Rail Corporation) over the IC tracks. People throwing rocks, particularly at night, is a hazard that railroaders face passing through Mattoon. In the photograph below, the train has just crossed Marshall Avenue as it enters the Mattoon yard, which had four tracks on each side of the two main line tracks. The yard office is located next to the tall pole and signal, which indicated whether the crew had train orders to pick up. (Photographs by Craig Sanders.)

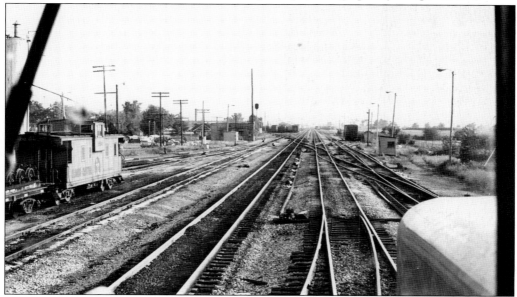

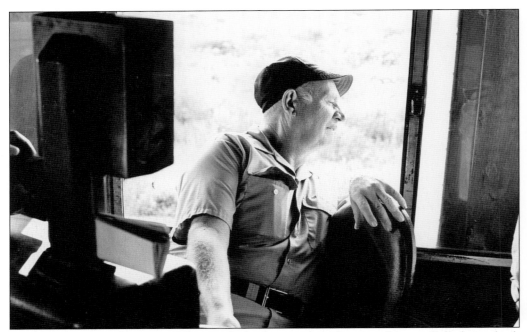

The ICG maintained a ramp in Mattoon for loading truck trailers onto flatcars. Called piggyback cars or "pigs" by railroaders, the Mattoon cars were picked up daily by Chicago–Memphis train No. 53. In the photograph above, engineer John Bassett looks out the window of his GP40 locomotive while picking up "pigs" in the Mattoon yard on August 10, 1977. Bassett, who had been an engineer for the past 15 years of his then 35-year railroad career, said he enjoyed the work and had many fond memories of working around steam-powered trains when he hired on with the IC. In the photograph below, the view is looking backward from the fireman's side as the train backs onto a track on the west side of the yard. (Photographs by Craig Sanders.)

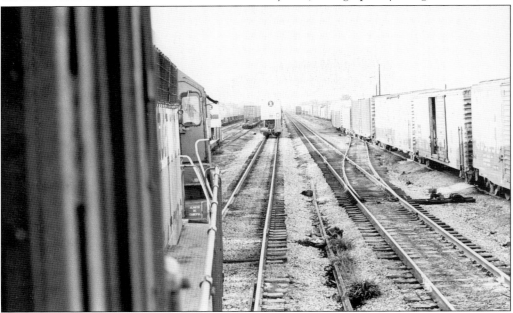

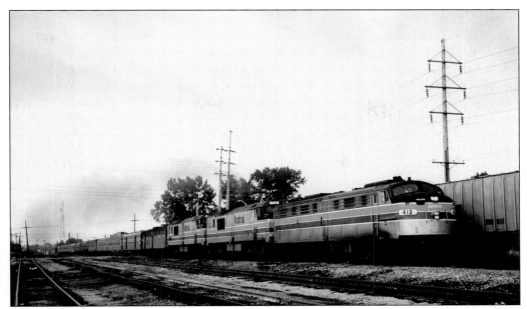

When it began operations on May 1, 1971, Amtrak kept just one of the IC's two Chicago–New Orleans passenger trains. Initially that was the daytime *City of New Orleans*, but on November 14, 1971, Amtrak placed the train on an overnight schedule, renumbered it 58 and 59, and revived the *Panama Limited* name. The northbound *Panama Limited* is shown in July 1976. (Photograph by James McMullen.)

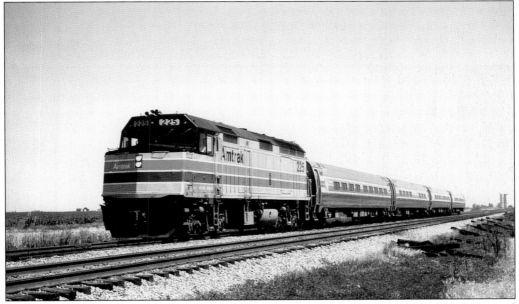

The Chicago–Carbondale *Shawnee* was the other Amtrak train serving Mattoon. It arrived southbound around noon and northbound about 6:00 p.m. The *Shawnee* received new Amfleet equipment on January 6, 1976. The *Shawnee* is shown in July 1976 being pulled by F40PH locomotive No. 225, which is only a few months old. The *Shawnee* was the second Midwest corridor train to receive new equipment. (Photograph by James McMullen.)

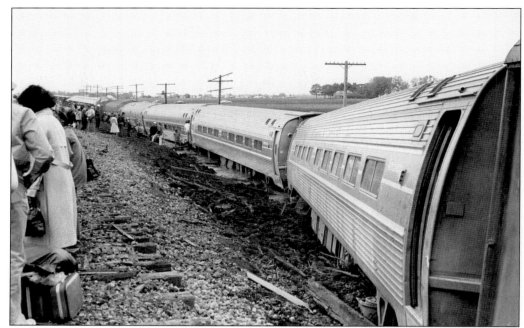

Amtrak's Chicago-bound *Panama Limited* derailed just south of Humboldt on May 7, 1980. Investigators blamed faulty track alignment. Fifty-one of the 151 aboard were hurt, including 10 who suffered serious injuries. The two locomotives and first two cars remained on the track, but the rest of the train landed in a drainage ditch, which cushioned the impact and kept the injuries from being more severe. (Photograph by Craig Sanders.)

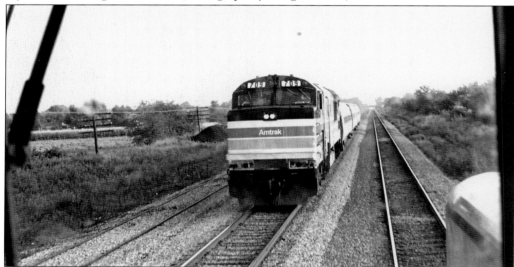

Due to a budget shortfall, Amtrak merged the Chicago–Carbondale *Shawnee* and the Chicago–Champaign *Illini* on January 12, 1986, and kept the *Illini* name for the surviving Chicago–Carbondale train. The Illinois Department of Transportation helps fund the *Illini*, which serves Mattoon in early evening in both directions. The northbound *Shawnee* is north of Mattoon on August 10, 1977, with P30CH No. 709 and three Amfleet cars. (Photograph by Craig Sanders.)

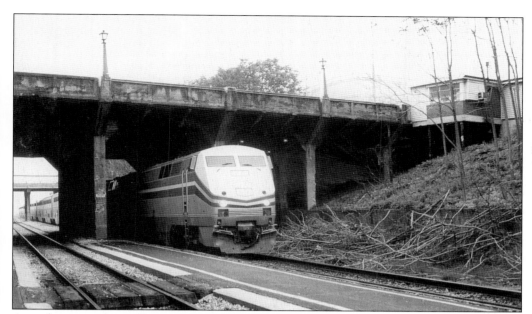

Amtrak renamed its Chicago–New Orleans *Panama Limited* the *City of New Orleans* on February 1, 1981, partly to capitalize on the popularity of the Steve Goodman song "City of New Orleans." The *City* received Superliner equipment on March 3, 1994, as part of a makeover that included reinstatement of full-service dining with meals freshly prepared onboard. The northbound *City* arrives in Mattoon on May 29, 1997. (Photograph by Craig Sanders.)

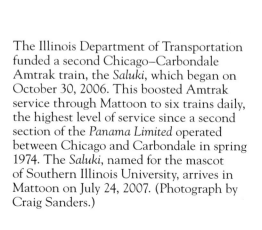

The Illinois Department of Transportation funded a second Chicago–Carbondale Amtrak train, the *Saluki*, which began on October 30, 2006. This boosted Amtrak service through Mattoon to six trains daily, the highest level of service since a second section of the *Panama Limited* operated between Chicago and Carbondale in spring 1974. The *Saluki*, named for the mascot of Southern Illinois University, arrives in Mattoon on July 24, 2007. (Photograph by Craig Sanders.)

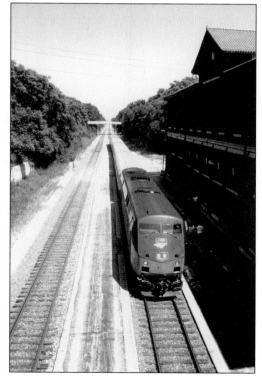

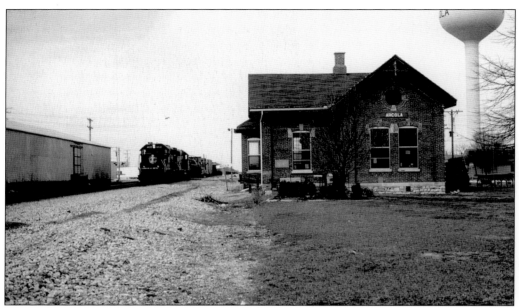

An old joke is that a man is riding an IC train when the conductor announces the stop at Arcola and, a few minutes later, Tuscola. The man says, "I suppose you are going to tell me that the next stop is Coca Cola." The conductor shakes his head. "No, it is Champaign." In the photograph above a train approaches the restored Arcola station. Passenger service ended here in March 1969, while Tuscola has been without service since April 30, 1971. In the photograph below, a southbound coal train passes TY tower in Tuscola. Southern Illinois is dotted with coal mines, and the IC was a heavy conduit of coal to Chicago area industries until Illinois coal lost favor because of high sulfur content. (Above, photograph by Craig Sanders; below, photograph by Robert Oliphant.)

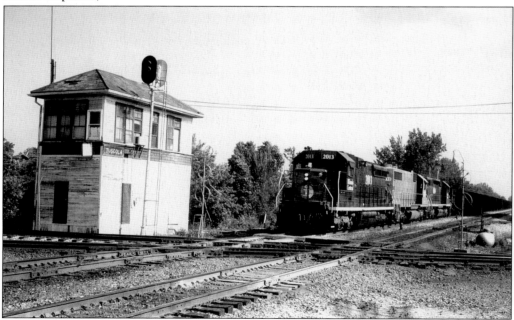

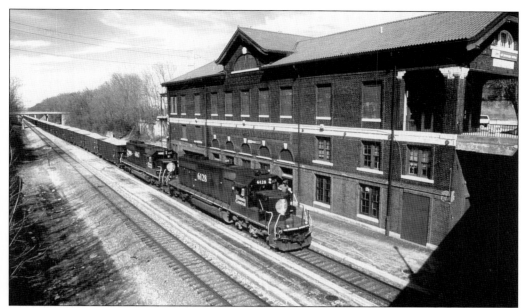

During the 1990s, the IC was North America's most efficient railroad with operating ratios (percentage of expenses to revenue) in the 60 percent range. The railroad achieved this, in part, by practicing scheduled railroading, a philosophy many railroads had abandoned in the 1950s. A southbound IC train of ballast hoppers led by SD40-2 No. 6128 passes the Mattoon passenger station in April 2005. (Photograph by Paul Burgess.)

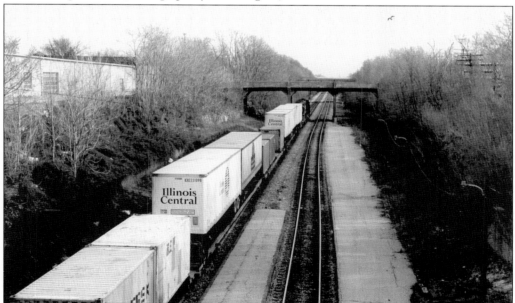

The ICG experienced mixed results in trying to capture the burgeoning intermodal business and considered giving it up altogether. In late 1989, the railroad offered to undercut truck rates by 20 percent on a three-month trial basis, and business picked up. In the early 1990s, the IC operated six daily intermodal trains, two of which passed through Mattoon. (Photograph by Craig Sanders.)

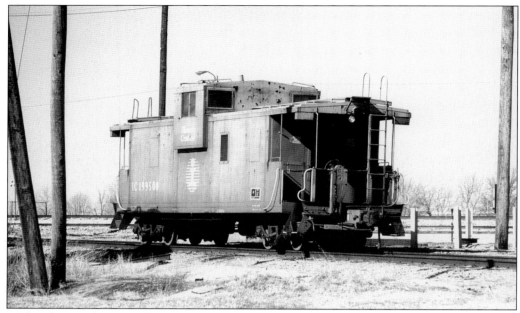

Railroads ceased using cabooses to cut costs. A few cabooses are still used on trains that do a lot of switching. Often the caboose is used as a platform on which a crew member stands and guides the engineer while making a backup move. This IC caboose reposes in the Mattoon yard on April 6, 1996, wearing gray paint and the company's "deathstar" logo. (Photograph by Craig Sanders.)

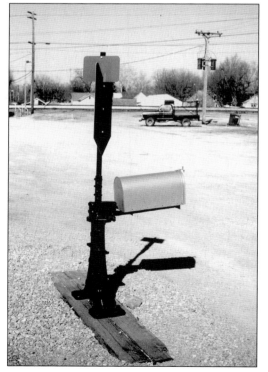

Old switch stands do not rust away, they become mailboxes. This IC switch stand has found a new purpose in life. The mailbox is mounted on the handle that railroaders used to throw the switch to realign the tracks. This switch stand mailbox is located near the IC yard office in Mattoon. (Photograph by Craig Sanders.)

The IC had a reputation for conservative management practices, but this approach enabled it to avoid financial difficulties. Unlike many railroads, the IC never spent time in receivership, although it came close to seeking bankruptcy protection in the 1930s during the depths of the Depression. A southbound IC local freight train saunters through Humboldt on April 4, 1996. (Photograph by Craig Sanders.)

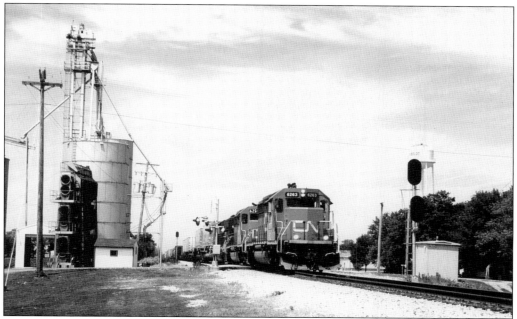

The IC was a profitable operation but a small player in a world dominated by much larger railroads. In February 1998, CN offered to buy the IC for $2.4 billion in cash and stock. The deal closed on July 1, 1999. IC locomotives were repainted in CN colors. SD40-3 No. 6263 leads a southbound train at Humboldt in June 2003. (Photograph by Paul Burgess.)

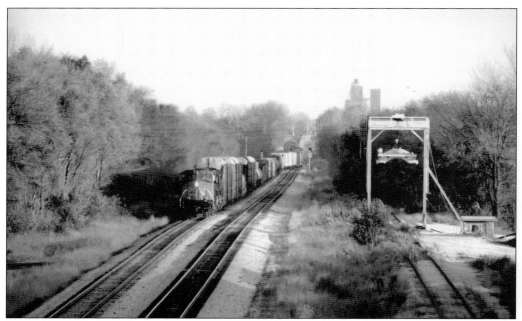

CN refers to its United States subsidiaries, including the IC, as CN and instructs employees to refer to themselves as CN employees even though there is no legal entity named CN. But the IC name endures, including IC initials on the flanks of CN locomotives. A southbound CN train is shown approaching the Dewitt Avenue bridge in Mattoon. (Photograph by Thomas French.)

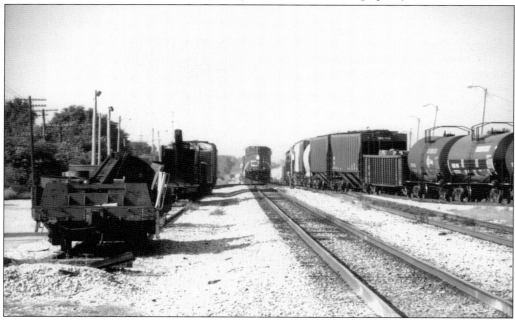

The former IC's Mattoon yard has diminished in importance but can still be a busy place sometimes. Primarily the yard is used as a drop-off and pickup point for through trains. No trains originate or terminate there. A northbound train waits on August 10, 2006, as the train to the right enters the yard on the line from Decatur and Peoria. (Photograph by Craig Sanders.)

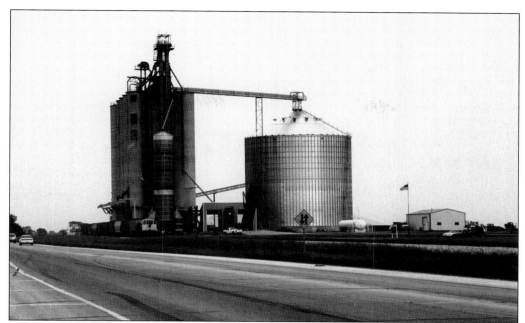

Nearly every central Illinois town has a grain elevator, but many of them lack rail service, a consequence of rampant railroad abandonment in the 1980s. Railroads continue to carry large quantities of grain because hauling grain over long distances by truck is impractical. Instead, trucks haul grain short and medium distances to regional grain elevators, such as the one shown in the photograph above at Coles, located northwest of Mattoon on the IC's Mattoon–Peoria line. Some regional elevators have their own locomotives to switch grain hopper cars and are capable of assembling 100-car unit trains. The photograph at right shows another part of the spectrum. The elevator at Jones, located southeast of Mattoon on the former Mattoon–Evansville line, also has a locomotive and purchased the track so it could move grain cars to Mattoon. (Photographs by Craig Sanders.)

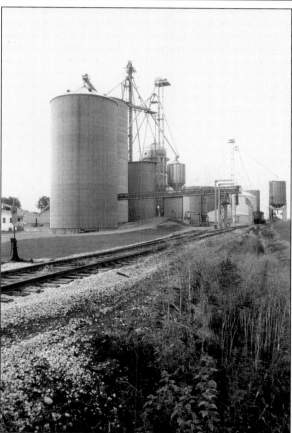

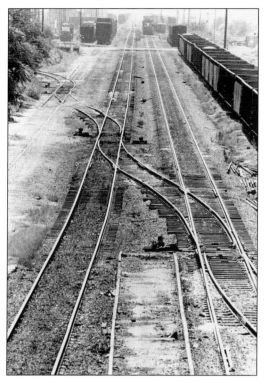

The IC infrastructure in Mattoon remained largely the same through the 1970s. As railroad operations changed, so did the infrastructure. In the photograph at left, taken in August 1978 from the Charleston Avenue bridge looking south toward the yard, the middle tracks are the main line. The far right track served a grain elevator and a connection from the NYC. The far left track ended at the passenger station and probably was used by Mattoon–Evansville, Indiana, passenger trains and, later, for storage. The track branching off and disappearing to the left led to the Evansville line and a wye. In the photograph below, taken from the same location in August 2006, only the main line tracks remain. Most tracks in the yard seen in the upper left in the photograph on the left are gone. (Photographs by Craig Sanders.)

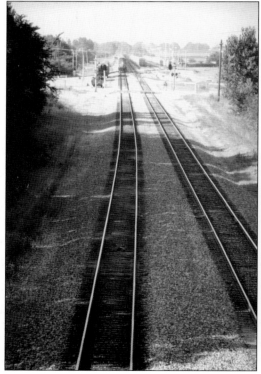

Passenger stations are designed to be noticed, but many railroad buildings are nondescript. This maintenance of way building used for decades by the IC in Mattoon was distinctive without calling much attention to itself or saying what it is. Mattoon residents who drove by it on Marshall Avenue probably have seen it many times without realizing its purpose or thinking much about it. (Photograph by Craig Sanders.)

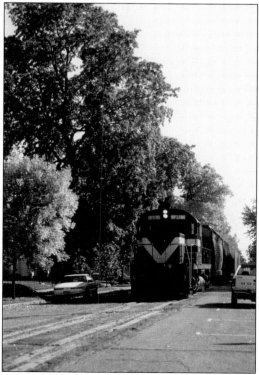

Indiana Hi-Rail Corporation (IHR) bought the ICG's Mattoon–Evansville line between Browns and Evansville in March 1986. IHR went bankrupt in 1994 and a spin-off operation, the Wabash and Ohio Railroad (W&O), operated the line. The Newton–Browns segment was abandoned on May 3, 1996. The rails between Browns and Poseyville, Indiana, were removed in 1999. A W&O train runs down the street in Olney in October 1994. (Photograph by Steve Patterson.)

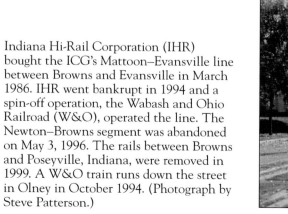

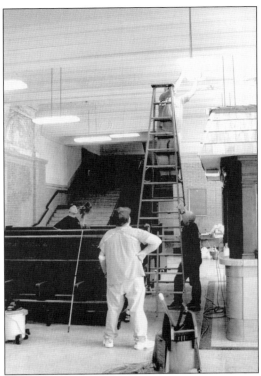

The City of Mattoon purchased the IC passenger station in spring 2001, and a committee of the Coles County Historical Society formed that June to seek funding to renovate the building. Plans include converting the station into a history museum. Periodically volunteers gather at the depot on weekends for cleaning and restoration work as shown here. The depot continues to serve Amtrak passenger trains. (Photograph by Thomas French.)

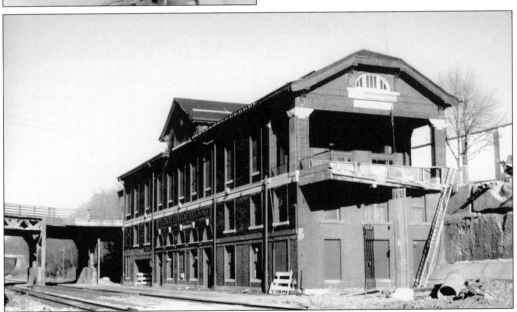

The replacement of the Broadway Avenue bridge in 2002 offered this rare view of the IC station in Mattoon. The IC once had several offices in the station, including the claim agent, maintenance of way foreman, district traffic agent, train master, and traveling auditor. All of these offices had closed by 1976, leaving the Amtrak ticket office as the last railroad function. (Photograph by Thomas French.)

Four

NEW YORK CENTRAL SYSTEM

In its halcyon days, the NYC was one of the nation's premier companies. The Vanderbilt family, which owned the NYC, held a controlling interest in the Big Four Railroad but did not lease it until 1930. Nonetheless, NYC heralds appeared on Big Four Railroad rolling stock. Some equipment was lettered New York Central Lines.

It was customary for residents along the NYC to refer to the company's trains by the name of a predecessor company. Thus in Mattoon and Charleston, the NYC continued to be called the Big Four. By the time of the February 1, 1968, merger of the NYC and the Pennsylvania Railroad (PRR), both companies were grappling with a declining industrial traffic base and excess capacity. The merger was doomed from the start because of poor planning and a clash of management styles. Penn Central Transportation Company entered bankruptcy on June 21, 1970. The nation's sixth-largest company had morphed into the largest bankruptcy in history.

The federal government created Consolidated Rail Corporation to take over assets of Penn Central Transportation Company and six other financially strapped eastern railroads on April 1, 1976. An infusion of public money helped Conrail rebuild its facilities while a change in the regulatory structure enabled it to shed thousands of miles of duplicate or lightly used routes.

Among the casualties was the former NYC route through Mattoon and Charleston. Although removed in 1983, its demise had been a long time coming. The 1968 creation of the Pennsylvania New York Central Transportation Company had put the future of the former NYC route in doubt. The former PRR route between Terre Haute and St. Louis via Effingham was 11 miles shorter, had better rail, more double track, fewer slow orders, and better St. Louis area yard facilities. The former NYC had better connections with western railroads, but after completion of a connection between the Alton and Southern Railroad and the former PRR line, the former NYC line became expendable as a path for through trains.

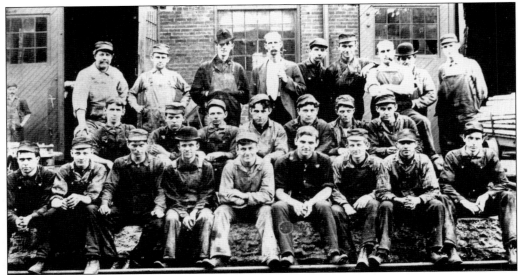

The I&StL agreed on December 20, 1869, to move its shops from Litchfield to Mattoon. The city donated 30 acres of land and issued $60,000 in bonds to finance the project. The railroad built machine, blacksmith, car, paint, and boiler shops and a 21-stall roundhouse. An 1870s report said the shops employed more than 200 with a $23,000 monthly payroll. (Courtesy of Mattoon Public Library.)

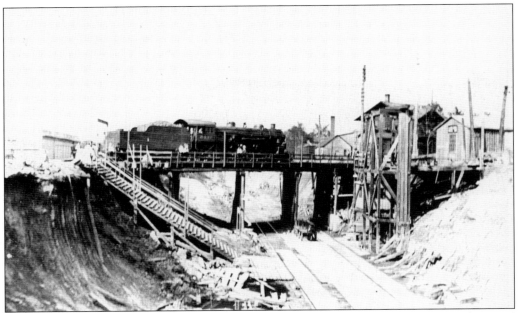

A Big Four Railroad locomotive moves over a wooden bridge over the IC in 1914. The wood bridge shown here soon was replaced by a substantial concrete structure that remained in place until being razed in early 2002. That occurred nearly 19 years after Consolidated Rail Corporation had removed the former Big Four Railroad tracks through Mattoon in May 1983. (Courtesy of Mattoon Public Library.)

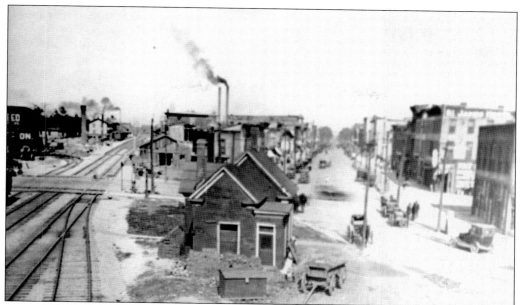

An early-20th-century view of Mattoon looking eastward shows the Big Four Railroad tracks and Broadway Avenue after the IC tracks were submerged below ground level. The track curving leftward was a connecting track between the two railroads. The grade crossing is Twenty-first Street, and the building in the foreground is on the site of today's Greyhound bus station. (Courtesy of Mattoon Public Library.)

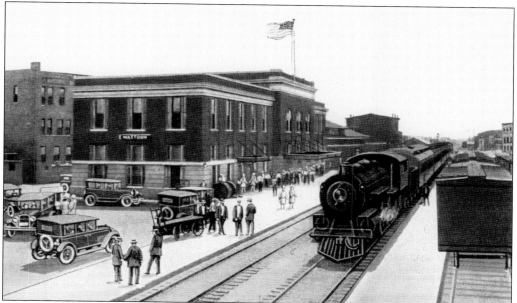

The Big Four Railroad opened a new Mattoon station on May 15, 1917. S. D. Mitchell and Son Company of Charleston built the two-story Beaux-Arts Classicism style structure for $50,000. The ticket office, waiting room, and baggage room were on the first floor while the second floor housed division offices. This image is taken from a postcard created shortly after the station's opening. (Courtesy of Mattoon Public Library.)

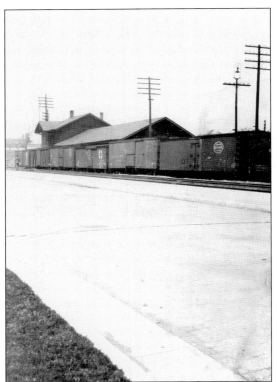

Seven boxcars wait at Mattoon's Big Four Railroad freight station. Thought to have been built in the 19th century, the facility later was moved slightly to the east to a location just west of Sixteenth Street. The freight station closed in 1961 and was razed in May 1963. In the foreground is the passenger platform and a driveway leading to the passenger depot. (Courtesy of Mattoon Public Library.)

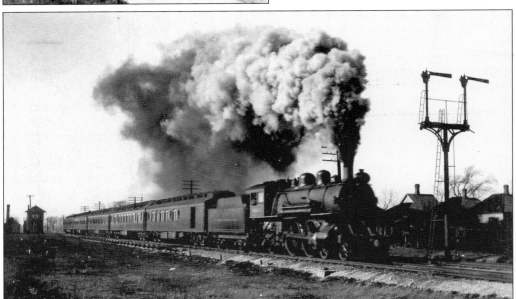

The NYC leased the Big Four Railroad on February 1, 1930, but had maintained financial control of it since the late 19th century. An eastbound passenger train smokes it up entering Mattoon in an undated photograph. The tower in the distance was named Karl and guarded the crossing between the NYC and the IC's Peoria line at Thirty-second Street. (Courtesy of Mattoon Public Library.)

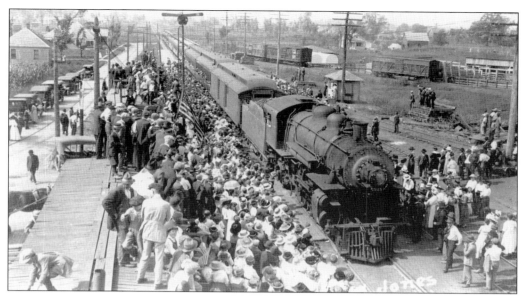

Charleston residents turned out in droves to say farewell to local men inducted into the United States Army during World War I. The inductees and their well-wishers gathered on the square and then marched to the Big Four Railroad station to board the train taking them to boot camp. In the photograph above, the train is arriving in the station from Mattoon. Note the automobiles parked at left on Railroad Avenue, which also had a streetcar line. In the photograph at right, the train is leaving for Terre Haute, Indiana. The building visible at the upper left is a freight station. In 1910, the Big Four Railroad operated 17 scheduled passenger trains through Charleston, although during the war this fell to 10 scheduled trains. Neither the passenger nor freight station has survived. (Courtesy of Nancy Easter-Shick collection.)

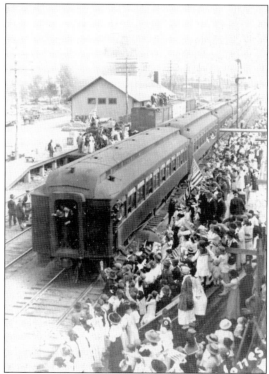

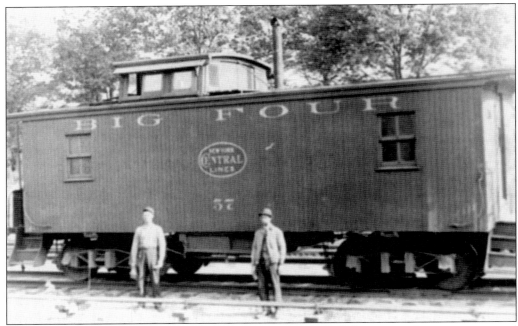

Railroads widely touted all-steel passenger cars in the early 20th century, but passengers and freight continued to travel in cars of wooden construction. Some people refused to ride in all-steel cars for fear of being electrocuted during a thunderstorm. In the photograph above, two Big Four Railroad crew members pose by a wooden caboose. Note the NYC logo, reflective of NYC control of the Big Four Railroad. The photograph probably was taken in Charleston, possibly near the crossing with the NKP. In the photograph below, workers unload Butter Boy popcorn from a Big Four Railroad boxcar in Mattoon in the early 20th century. Although motor vehicles were beginning to grow in popularity, freight was still unloaded onto horse-drawn wagons. (Above, courtesy of Nancy Easter-Shick collection; below, courtesy of Coles County Historical Society.)

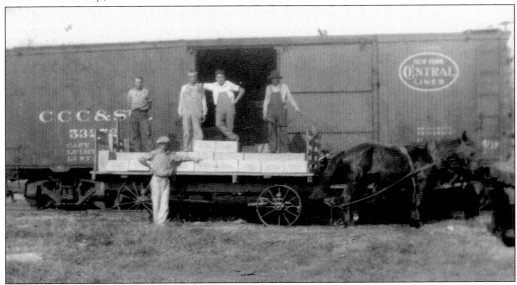

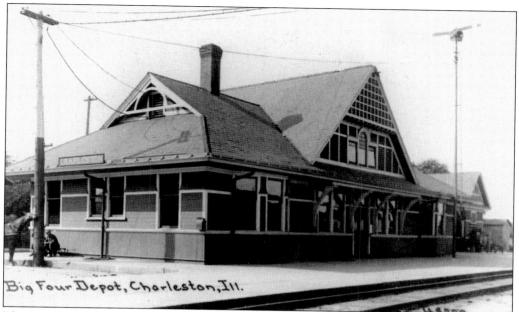

The Big Four Railroad began construction of a new Charleston passenger station in October 1903. Some homes were moved or demolished in 1902 to make room for the facility. Built on the site of the original depot, the new frame station cost $10,000 and featured a general waiting room, women's waiting room, and smoking room. The station opened in 1904. (Courtesy of Nancy Easter-Shick collection.)

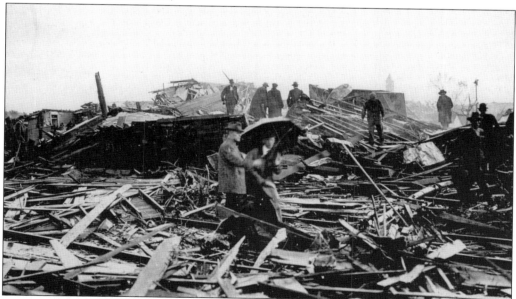

A devastating tornado struck Mattoon and Charleston on May 26, 1917, leaving 64 dead and 467 injured in Mattoon, and 50 dead and 150 injured in Charleston. The storm traveled nearly 300 miles through Missouri, Illinois, and Indiana, making it one of the longest-traveled tornadoes on record. The tornado destroyed the Big Four Railroad station in Charleston, as seen in this photograph. (Courtesy of Coles County Historical Society.)

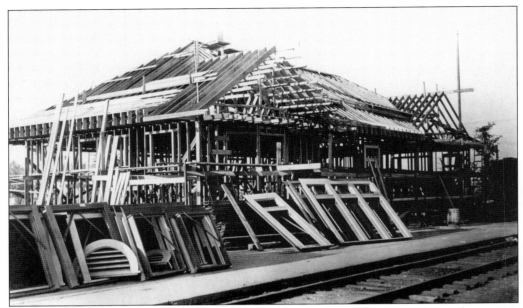

Work began immediately to rebuild Charleston's Big Four Railroad station after its destruction during a 1917 tornado. The basic framework of the building has been erected, and window frames are waiting to be put into place. Aside from destroying this railroad station, the tornado also severely damaged or destroyed more than 800 homes, churches, schools, and factories in Charleston and Mattoon. (Courtesy of Nancy Easter-Shick collection.)

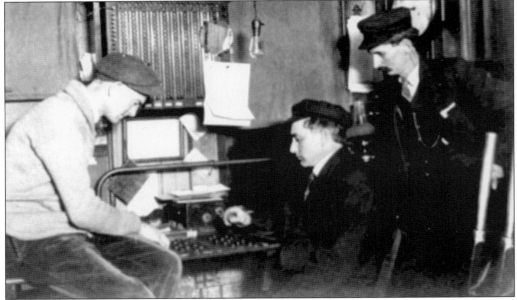

Every town with a railroad had a train station. Shown here is the Big Four Railroad station in Ashmore where the men are engaged in a game of checkers. Perhaps they are waiting for another train to arrive or pass by. The levers at right controlled the station's order board, a semaphore used to signal passing trains that they had train orders to pick up. (Courtesy of Nancy Easter-Shick collection.)

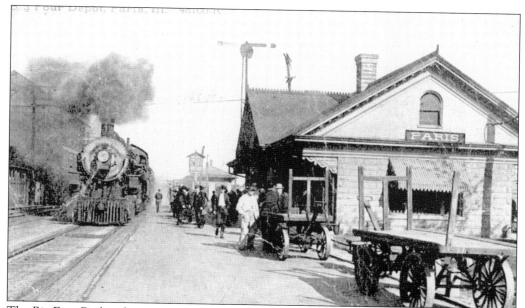

The Big Four Railroad station is shown at Paris in an early-20th-century view. Paris, the county seat of Edgar County, had three railroad lines, including a Big Four Railroad route between Chicago and Cairo. The third railroad was the PRR's line between Terre Haute and Peoria. Paris also hosted Midland Yard on the Big Four Railroad's St. Louis line. (Courtesy of Mark Camp collection.)

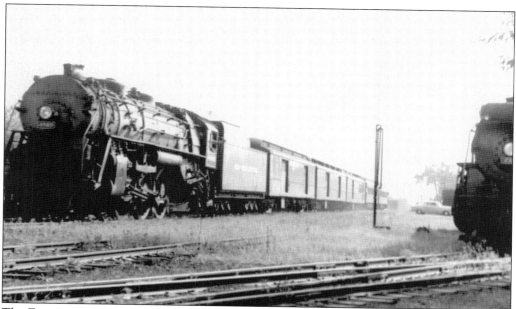

The *Egyptian* was an overnight train between Chicago and Cairo via Paris. The name reflected the nickname of deep southern Illinois as Little Egypt. The *Egyptian* carried a sleeping car, typically a 10-section, three-double-bedroom heavyweight car. Begun on September 26, 1926, the *Egyptian* began terminating at Harrisburg on June 22, 1941, and made its final trips on May 4, 1957. (Photograph courtesy of Lawrence Baggerly.)

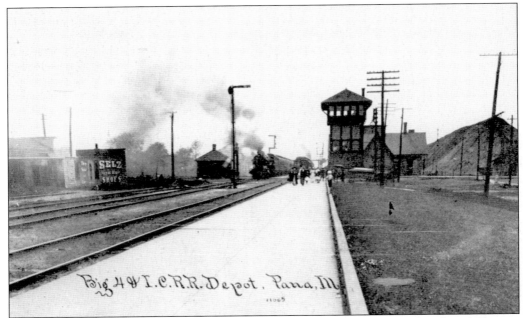

Pana was the crossroads of four railroads: NYC, IC, Baltimore and Ohio Railroad, and Chicago and Eastern Illinois Railway (C&EI). The last IC passenger service was a Decatur–Centralia train that ended on May 28, 1933. Today just one railroad route passes through Pana. The Union Pacific Railroad uses former C&EI track east of Pana and former NYC track west of there. (Courtesy of Mark Camp collection.)

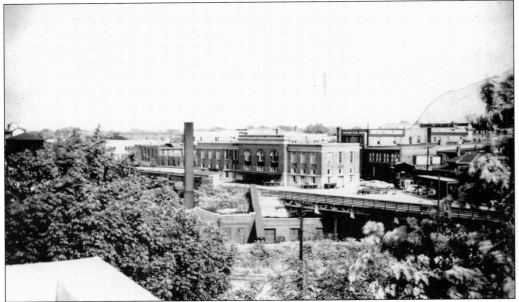

The NYC station in Mattoon is shown in an undated view looking southeast that may have been taken from city hall. The smokestack is for a power plant that jointly served the NYC and IC passenger stations. Note the covered stairway leading from the NYC platform over the power plant to the IC platform, which is out of view below. (Courtesy of Mattoon Public Library.)

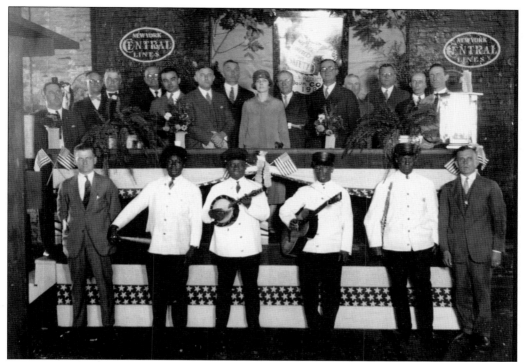

The NYC held a banquet in Mattoon to honor its employees for making 1921 a safe year on the railroad. Providing entertainment was a musical ensemble known as Noon Train. It is not clear if the musicians were Pullman porters who played music on the side or musicians dressed up as Pullman porters. The location of the banquet is unknown. (Courtesy of Mattoon Public Library.)

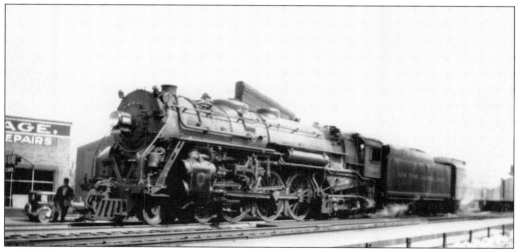

A NYC passenger train pauses in Mattoon about 1930. Locomotive 6609, a J1-d Hudson built by American Locomotive Works in Schenectady, New York, in December 1929, is owned by the Big Four Railroad. Service between St. Louis and Cleveland crested in 1930 at seven round-trips. The *Southwestern Limited* and *Knickerbocker* raced between New York and St. Louis in 23 hours. (Courtesy of Jay Williams collection.)

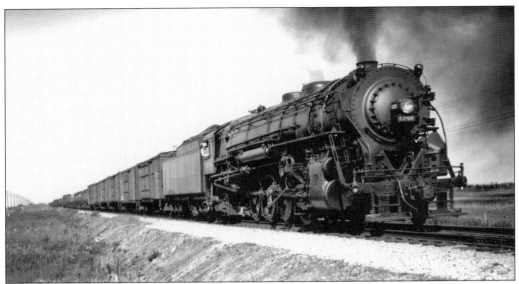

Because much of the NYC involved relatively flat terrain, the company's steam locomotives tended to be designed for fast running. This was particularly the case on the Illinois prairie where the track was mostly straight. NYC No. 6208, a 4-8-2, is shown near Mattoon on August 15, 1933. (Photograph by Otto Perry, courtesy of Denver Public Library, Western History Collection, OP 13613.)

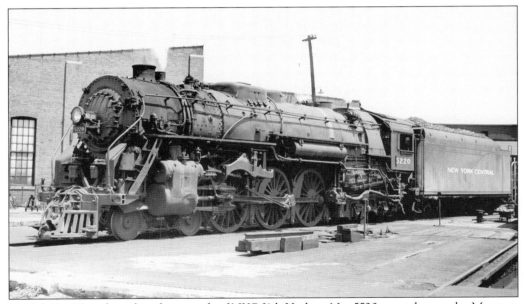

On July 3, 1954, when this photograph of NYC J1-b Hudson No. 5520 was taken at the Mattoon roundhouse, the hour was getting late for the steam era on this corner of the railroad. By 1952, all passenger trains on the St. Louis line were being pulled by diesel locomotives except the westbound *Cleveland-St. Louis Special* and the eastbound *Cleveland-Cincinnati Special*. (Courtesy of Jay Williams collection.)

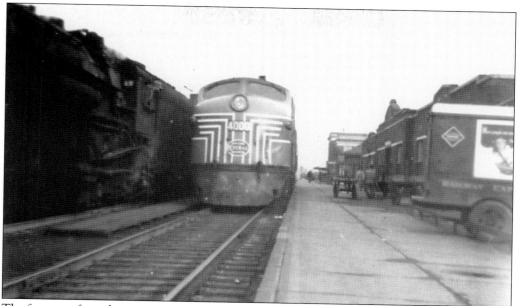

The fireman of an adjacent train seems to be admiring NYC E7A No. 4000 as it waits in Mattoon with the westbound *Knickerbocker* or *Southwestern Limited*. For a brief time in the late 1940s, the NYC carried through cars between New York and Texas, which interchanged at St. Louis with the Missouri Pacific Railroad or the St. Louis–San Francisco Railway (Frisco). (Courtesy of Coles County Historical Society.)

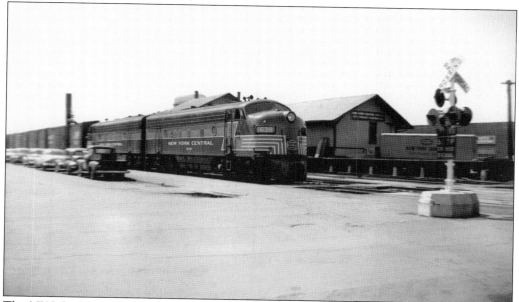

The NYC had a vast fleet of modern and powerful steam locomotives in the late 1940s but embarked on an aggressive campaign to replace steam engines with diesel power. In part this was because of the cost savings realized from switching to diesels. The future of NYC locomotive power is shown as an eastbound freight train crosses Sixteenth Street in Mattoon. (Photograph by Donald Cleveland.)

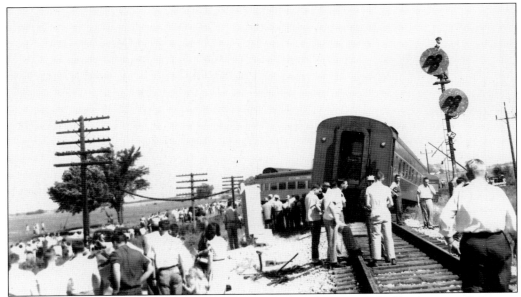

NYC's eastbound *Southwestern Limited* struck a gravel truck two and a half miles east of Mattoon on September 20, 1954. Nine aboard the train were hospitalized in serious condition, with one in critical condition. The truck driver was killed. All available ambulances in Mattoon and surrounding towns came to the scene. Twelve of the 14 cars derailed, with four cars turning over. (Courtesy of Nancy Easter-Shick collection.)

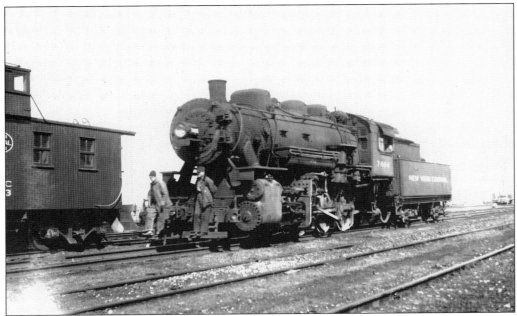

The NYC had 351 steam locomotives on its motive power roster on January 1, 1956, but many were retired in the early months of that year. Shown is 0-8-0 No. 7406 performing switching duties in the Mattoon yard on March 20, 1956. The last NYC steam locomotive dropped its fires on May 2, 1957, in Cincinnati. (Photograph by Lloyd E. Stagner.)

The Big Four Railroad created the *Southwestern Limited* on October 6, 1889, as its St. Louis–New York signature train. It became all Pullman on April 26, 1925. The NYC boasted that it was second only to the *Twentieth Century Limited*, the NYC's Chicago–New York flagship train, in opulence. The *Southwestern Limited* offered club cars, a ladies maid, a valet, a stenographer, stock market reports, and private room sleeping cars. Some sleepers served Boston. During World War II, the NYC operated 12 scheduled passenger trains through Mattoon exclusive of second sections and extras. The *Southwestern Limited* received lightweight streamlined equipment in the late 1940s but was not completely streamlined until 1953. In the photograph at right, the westbound *Southwestern Limited* is west of Paris in 1951. The photograph below shows the observation car. (Photographs by Lawrence Baggerly.)

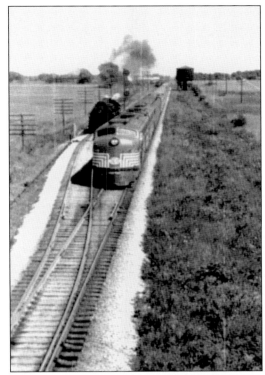

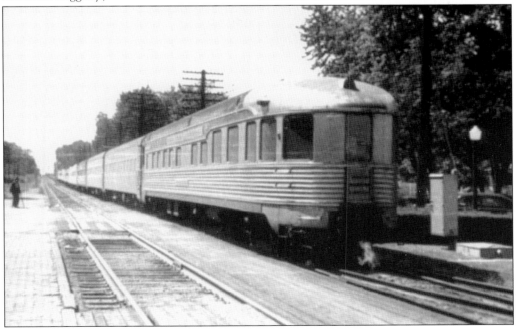

For decades, scores of men worked in Mattoon for the NYC. Some carried suitcases for overnight travel as they went about their duties as engineers, conductors, brakemen, or trainmen. Others carried lunch pails as they reported to work in the shops, the roundhouse, or offices in the passenger station. Mattoon ceased being a division headquarters for the NYC in 1964, and employment would soon dwindle. Four years later, the Mattoon terminal was eliminated for through trains. Many trainmen were transferred to Indianapolis, and employment on the former NYC in Mattoon became minimal. An unidentified photographer took these photographs of railroaders going about their jobs in Mattoon in the mid-1960s. Neither the engineer in the photograph above nor the crew caller in the photograph below were identified. (Courtesy of Coles County Historical Society.)

Railroad work had its rituals and routines. For over-the-road trainmen, it began with a call about two hours before they were to report for duty. At the end of the job there was paperwork to be completed. An unidentified NYC trainman fills out a time slip in the Mattoon yard after the end of a run in the mid-1960s. (Courtesy of Coles County Historical Society.)

It was customary for the wife of a railroad locomotive engineer to accompany her husband when he made its final run before retirement. Charles Bulla and his wife, whose name was not recorded, are shown in Mattoon on December 20, 1964. Bulla was the engineer for passenger train No. 312, the St. Louis–Cleveland *Southwestern*. (Courtesy of Coles County Historical Society.)

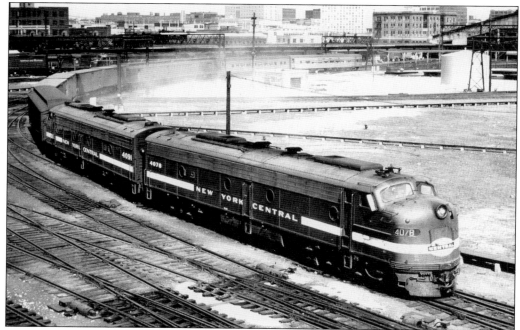

The NYC sought to eliminate all passenger service on the St. Louis line west of Indianapolis in 1957. Four of the eight trains ended on August 17, 1958. Two more trains ended on April 26, 1959, leaving only the westbound *Knickerbocker* and eastbound *Southwestern*, which is shown leaving St. Louis for Mattoon on April 2, 1967. Nos. 312 and 341 made their final trips on March 18, 1968.

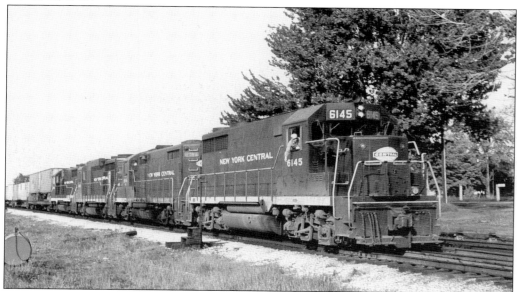

The NYC redesigned its famed oval logo in the 1960s and simplified the livery on its locomotives to a minimalist design. At the same time, the NYC began repainting its boxcars and cabooses in a shade of jade green. An NYC freight train shows the new look on May 23, 1965. (Photograph by James McMullen.)

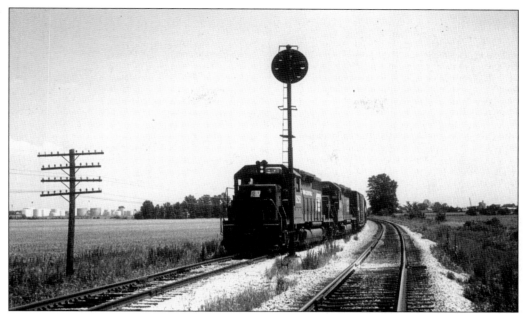

Penn Central Transportation Company's fastest trains used the former PRR route through Effingham between St. Louis and Terre Haute, Indiana. Railroaders called the former PRR route the "south line" and the former NYC route via Mattoon the "north line." A westbound local that had been switching at the Velsicol plant at Marshall is waiting for an opposing train on July 22, 1972. (Photograph by Jeff Pletcher.)

Most freight trains on the former NYC route operated westbound after the creation of Penn Central Transportation Company in 1968 because the NYC had better connections to western railroads at St. Louis. This operating pattern continued after Consolidated Rail Corporation took over Penn Central Transportation Company in 1976. A westbound Conrail train crosses over the ICG in Mattoon in early 1977. (Photograph by Craig Sanders.)

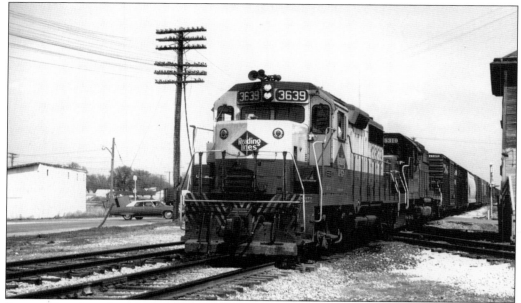

Seven railroads, only one of which was not bankrupt, were combined on April 1, 1976, to create Consolidated Rail Corporation. Conrail began with 5,000 locomotives, all of them bearing the markings of its predecessor railroads, and dispersed them throughout its 17,000-mile system. A former Reading Company locomotive leads a westbound Conrail manifest freight train past CO tower in Charleston in April 1977. (Photograph by Craig Sanders.)

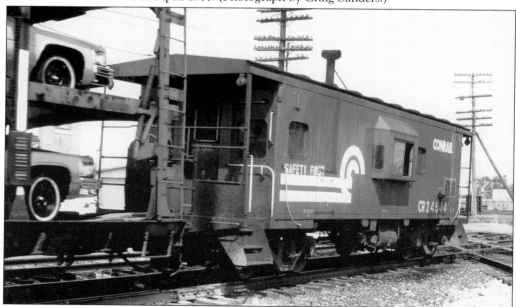

A former NYC caboose passes through Charleston in April 1977 bearing Conrail colors and logo. It is the third livery this car has worn, having also been in Penn Central Transportation Company dress for several years. Conrail began life with $2.1 billion in federal money and used public funds to pay for track rehabilitation and new equipment, things its predecessors had neglected for years. (Photograph by Craig Sanders.)

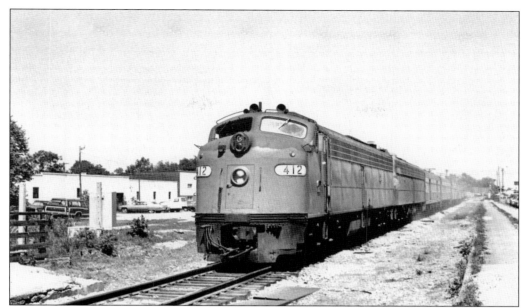

Amtrak's New York–Kansas City *National Limited* was scheduled to use the former PRR route between Terre Haute and St. Louis via Effingham, but it sometimes detoured over the former NYC line via Mattoon. The westbound *National Limited* is about to stop in Mattoon in May 1977 near the former NYC passenger station. These periodic detours continued through August 1979. (Photograph by Craig Sanders.)

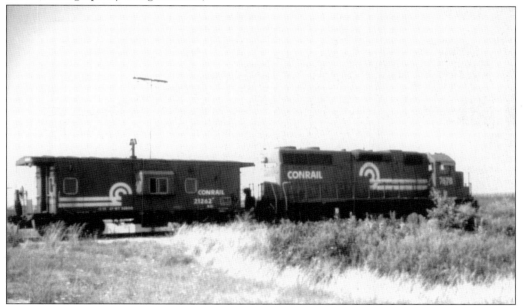

Conrail ceased routing through trains over the former NYC through Mattoon in mid-1980. Conrail delivered little freight locally because many shippers thought the service was poor. Paper shipments from Wisconsin that a truck could deliver overnight took 7 to 10 days by rail. The last trains were locals with a locomotive and caboose similar to those shown here near the Lerna Road. (Photograph by Leland Warren.)

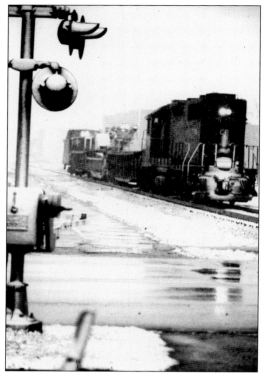

By the time these photographs were taken in early April 1982 during a late season snowstorm, Conrail had received permission to abandon its line through Mattoon and Charleston. Therefore, this train may have been sent out to retrieve equipment that will be moved off line. In the photograph at left, a locomotive running long hood forward approaches the crossing at Sixteenth Street alongside the Mattoon passenger station platform. In the photograph below, the crew members seem to be contemplating the past as they watch from the rear of a former PRR caboose. Could these men be making their last trip over these rails? If not, there are likely few trips left for them to make. The next trains to use these rails will be work trains that will be removing the rails and other infrastructure. (Photographs by Craig Sanders.)

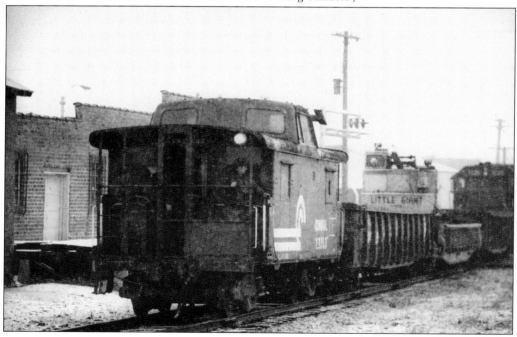

Five

NICKEL PLATE ROAD

The Transportation Act of 1920 encouraged railroad consolidation, and the NKP, a Chicago–Buffalo railroad, acquired the Toledo, St. Louis and Western Railroad (TStL&W) in 1923 to gain access to the St. Louis railroad gateway. The TStL&W, known as the Clover Leaf Route, had a long history of financial distress sparked by high operating costs, low profits, and strong competition. Its wandering and not always well-built route posed difficult operating and engineering problems.

When completed in 1883, the Clover Leaf Route was part of a 1,600-mile chain of narrow-gauge railroads between Ironton, Ohio, and the Brazos River west of Houston, Texas. At 550 miles, the Clover Leaf Route was the longest narrow-gauge railroad east of the Mississippi River. Transferring freight between narrow-gauge and standard-gauge railroads was expensive and time-consuming, so the Clover Leaf Route converted to standard gauge in the late 1880s.

At the time of the NKP acquisition, passenger service on the former Clover Leaf Route through Charleston typically included two pairs of Toledo–St. Louis trains. Local passenger trains, which sometimes operated as mixed trains, ran between Charleston and East St. Louis, Illinois, and Charleston and Frankfort, Indiana. The Charleston–Frankfort trains ended on July 11, 1932, while the Charleston–East St. Louis trains lasted until April 28, 1952.

The last NKP passenger trains through Charleston were Cleveland–St. Louis Nos. 9 and 10. Begun on February 19, 1928, Nos. 9 and 10 were, arguably, the least heralded NKP long-distance trains. They went unnamed until October 28, 1956, when No. 9 became the *Blue Arrow* and No. 10 became the *Blue Dart*.

Nos. 9 and 10 carried coaches, a sleeper, and a diner-lounge. Patronage was light, but the losses incurred by the trains were not excessive. The diner-lounge ceased operating west of Lima, Ohio, in June 1957. After Nos. 9 and 10 lost $400,000, the NKP sought permission from regulatory bodies in Illinois, Indiana, and Ohio to remove the trains. The Illinois Commerce Commission acted first, and the *Blue Arrow* and *Blue Dart* stopped in Charleston for the final time on March 14, 1959.

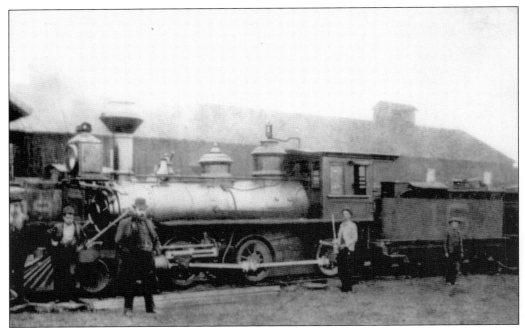

Toledo, St. Louis and Kansas City Railroad No. 16 reportedly pulled the first narrow-gauge train from Toledo to St. Louis in 1883. It is shown in Charleston in 1889, the year that conversion to standard gauge was finished west of here. At that time, through passengers bound for St. Louis had to change trains at Charleston and endure a 12-hour layover. (Courtesy of Nancy Easter-Shick collection.)

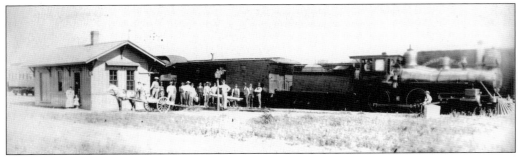

The Toledo, Cincinnati and St. Louis Railroad began building between Charleston and St. Louis in May 1881. The first train operated from Charleston to Neoga on March 11, 1882, but financial problems halted construction and prevented the line from opening until 1883, when mixed train service began on May 14. Toledo–St. Louis express service began that summer. A passenger train is shown at Fillmore. (Courtesy of Nancy Easter-Shick collection.)

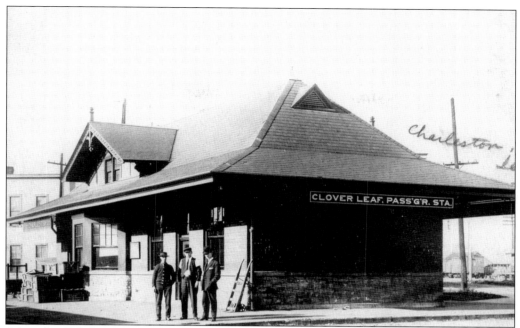

After the Toledo, Cincinnati and St. Louis Railroad entered receivership in August 1883, a judge ordered passenger service slashed to a bare minimum on January 6, 1885—a mixed train in each direction. It would be five years before Toledo–St. Louis service resumed, in part because the track was in poor condition. The Charleston passenger station is shown in the early 20th century. (Courtesy of Coles County Historical Society.)

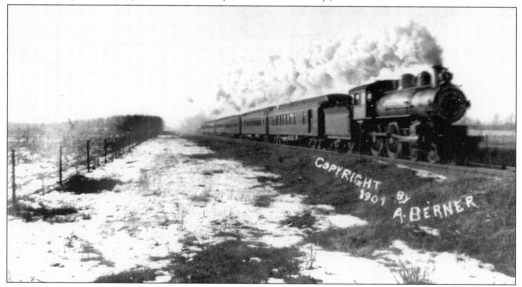

At the beginning of the 20th century, the Clover Leaf Route had two pairs of Toledo–St. Louis passenger trains. Unable to match the speed of the Wabash Railroad in that market, the Clover Leaf Route sought to offer better on-board service. In hyperbole typical of railroad advertisements in that era, it bragged in the *Official Guide of the Railways* of offering "perfect passenger service." (Courtesy of Nancy Easter-Shick collection.)

Formally known as the New York, Chicago and St. Louis Railroad, the NKP got its moniker from Ohio newspaper editor F. R. Loomis. Taking note of the proposed railroad's glittering financial condition, Loomis labeled it "the great New York and St. Louis double track, nickel plated railroad." C. Eyrse (left) and B. Maloy pose in the 1920s. Eyrse later became the trainmaster in Charleston. (Courtesy of Nancy Easter-Shick collection.)

In January 1901, the Clover Leaf Route overnight St. Louis–Toledo trains received 13-hour schedules, new equipment, and the name *Commercial Traveler.* Dubbed the "King of the Rails," its popularity with Niagara Falls–bound newlyweds led to the *Commercial Traveler* being dubbed the "Honeymoon Special." Toledo–St. Louis through sleepers and coaches ended on May 3, 1931, and the last remnant of the *Commercial Traveler* ended on April 4, 1943. (Courtesy of Nancy Easter-Shick collection.)

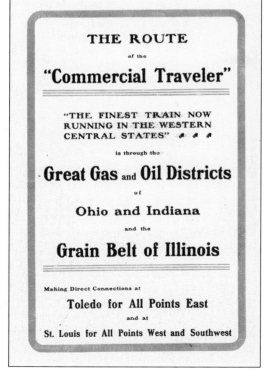

THE ROUTE
of the

"Commercial Traveler"

"THE FINEST TRAIN NOW RUNNING IN THE WESTERN CENTRAL STATES" ✦ ✦ ✦

is through the

Great Gas and Oil Districts

of

Ohio and Indiana

and the

Grain Belt of Illinois

Making Direct Connections at

Toledo for All Points East

and at

St. Louis for All Points West and Southwest

In the minds of many, a railroad roundhouse is most often associated with steam locomotives. The Charleston roundhouse, shown in the photograph above, was built by the Clover Leaf Route and used by the NKP through the 1950s. Following a 1906 renovation of its Charleston shops, the roundhouse had 12 stalls. During this era, the Clover Leaf Route employed more than 226 workers and was for a time the city's largest employer. Even a hotel was named after the Clover Leaf. In 1955, the NKP said that the impending replacement of steam locomotives with diesels would mean the removal of the Charleston roundhouse, coal dock, and sand house. In the photograph below, NKP Charleston trainmaster C. Eyrse discusses railroad operations with two unidentified men. (Courtesy of Nancy Easter-Shick collection.)

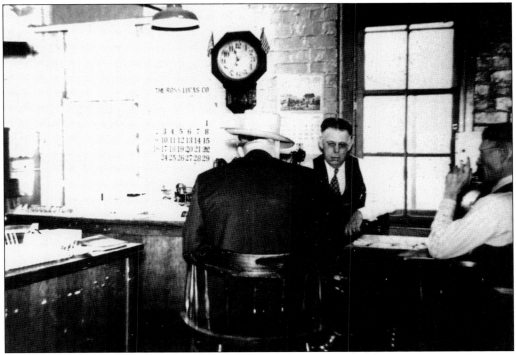

A caboose was a combination office and home away from home for the conductor and the other trainmen who inhabited it while out on the road. It was common for a conductor to be assigned to a particular caboose. When that conductor was on vacation, if another conductor and crew used the caboose, there was an understanding that everything had better be put back exactly the way it was when the crew first stepped aboard its borrowed caboose. In the photograph above, NKP conductor L. "Curley" Middlesworth works in his caboose in 1945. Aside from the usual railroad paperwork found in any caboose, Middlesworth has surrounded himself with a lamp, radio, and various pictures. In the photograph below, an unidentified conductor poses by his caboose in about 1950. (Courtesy of Nancy Easter-Shick collection.)

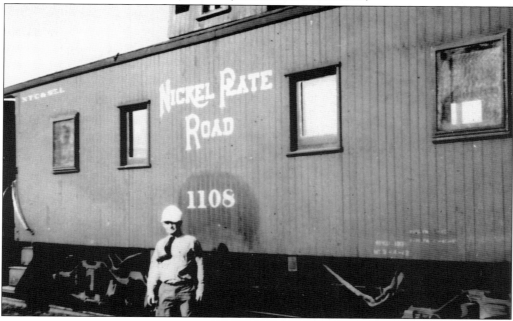

Today's railroaders stay in touch with dispatchers and other supervisors via radio or cell phones. Railroaders of the past also used telephones to call dispatchers, but only if they happened to be near a trackside telephone booth. The ubiquitous "telephone lines" that lined railroad tracks carried the railroad's private telephone system. W. Marlot is shown making a call around 1920. (Courtesy of Nancy Easter-Shick collection.)

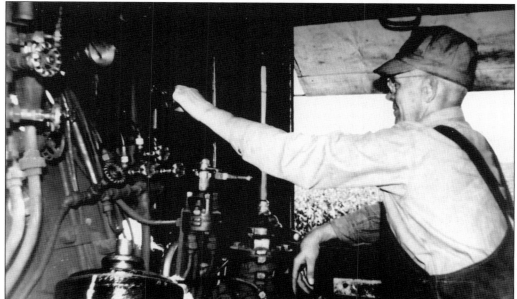

NKP veteran engineer J. Doty has a steam locomotive under control in a photograph taken about 1950. But in less than a decade, steam locomotives will be gone from the NKP in Charleston. Cleveland–St. Louis passenger trains Nos. 9 and 10 received Alco PA diesel locomotives on March 21, 1948, replacing aging K-1 Pacific locomotives assigned to those trains since 1930. (Courtesy of Nancy Easter-Shick collection.)

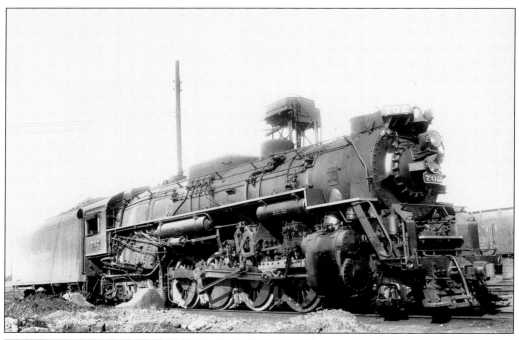

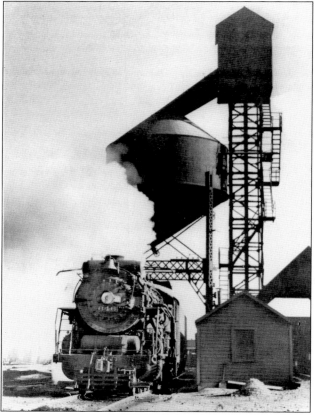

Steam locomotive power was seldom assigned to NKP passenger trains after 1952 except for troop trains, baseball specials, and other special occasions. But steam still pulled many freight trains through the late 1950s. In 1955, the NKP announced that 32 GP-9 diesel locomotives built by the Electro-Motive Division of General Motors Corporation were expected to replace steam power on the Clover Leaf District—the segment of the NKP serving Charleston—by August 1, 1955. The first of these diesels entered service on July 1, 1955. In the photograph above, NKP steam locomotive No. 702 (a 2-8-4 built in September 1934) awaits its next assignment as it reposes in the Charleston yard. In the photograph at left, No. 646, a 2-8-2 built in December 1923 by Lima Locomotive Works, takes on coal. (Above, courtesy of Jay Williams collection; left, courtesy of Nancy Easter-Shick collection.)

The former Clover Leaf Route was not engineered for high speeds, as was the NKP's Chicago line, but the St. Louis line did a respectable business of carrying meat, livestock, and perishables out of St. Louis. A NKP freight train is shown at Charleston behind a 2-8-2 steam locomotive built by Lima Locomotive Works in December 1923. (Courtesy of Nancy Easter-Shick collection.)

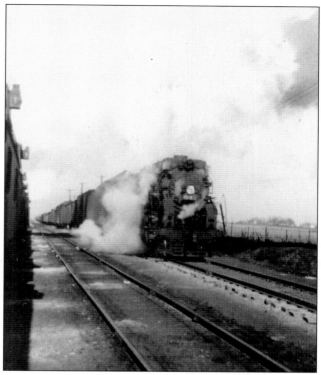

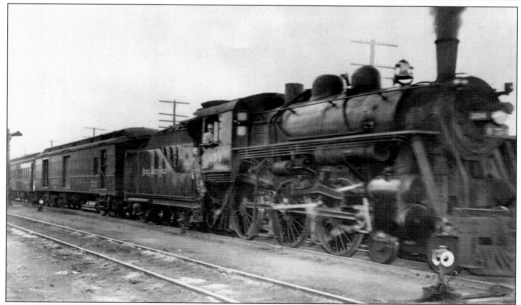

Nos. 11 and 12 were the last locals on the former Clover Leaf Route. They departed Charleston at 6:00 a.m., made 19 stops en route to East St. Louis and returned at 7:15 p.m. The trains ended on January 13, 1950, were reinstated two months later, and were discontinued on April 28, 1951. Locomotive No. 154 is shown with a passenger train in the 1940s. (Courtesy of Nancy Easter-Shick collection.)

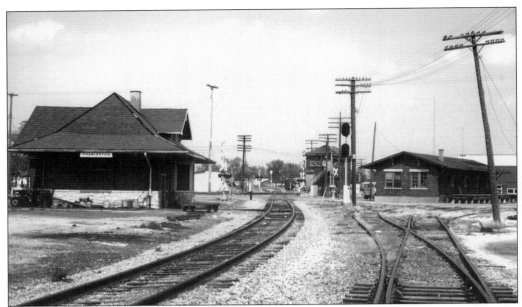

Larger towns had a passenger station and a freight station. The two were often adjacent. In smaller towns, passengers and freight were handled from the same building. Freight stations typically handled less-than-carload freight shipments. In Charleston, the NKP passenger and freight stations each were located on Fourth Street between Washington Avenue and Railroad Avenue. The photograph above shows the passenger station, a portion of the freight station and the tower controlling the crossing of the NKP and the NYC. Both stations have survived, although the passenger station in 2007 was vacant. The Eastern Illinois Railroad, which operates the former NKP in Charleston, drops off occasional cars of lumber at the freight station for unloading. The freight station is shown in the photograph below in April 1977. (Photographs by Craig Sanders.)

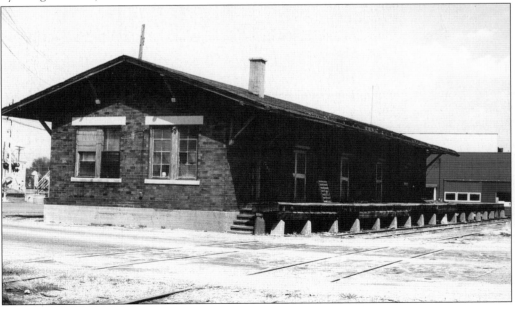

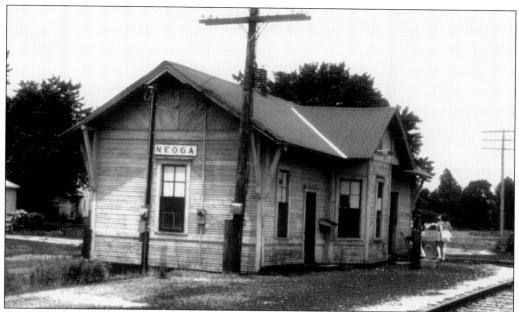

The NKP merged with the Norfolk and Western Railway (N&W) on October 16, 1964. That same day N&W leased the Wabash Railroad, which had a better route to St. Louis and more on-line traffic than the former NKP. The N&W and Southern Railway created Norfolk Southern Corporation on June 1, 1982. Shown is the former NKP depot at Neoga. (Photograph by John Fuller.)

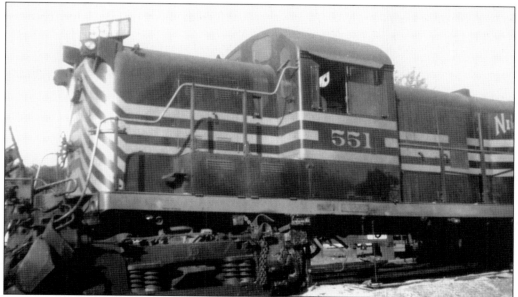

NKP No. 551 has jumped the rails in Charleston in a minor accident. No. 551 is an Alco RS-3 built in March 1954 and retired on March 29, 1972. The earliest NKP diesel locomotives were switch engines. The company took delivery of 11 Alco PA1 passenger locomotives in 1947–1948. These were nicknamed "Bluebirds" for their blue and gray livery. (Courtesy of Coles County Historical Society.)

Grabbing orders on the fly has largely vanished from American railroading. Today train orders are sent electronically or by radio. A westbound N&W crew picks up orders at Tolono on May 27, 1978. The bottom hoop has orders for the crew in the caboose. The crossing railroad is the IC main line between Champaign and Mattoon. The Tolono depot has since been razed. (Photograph by David Tiffany.)

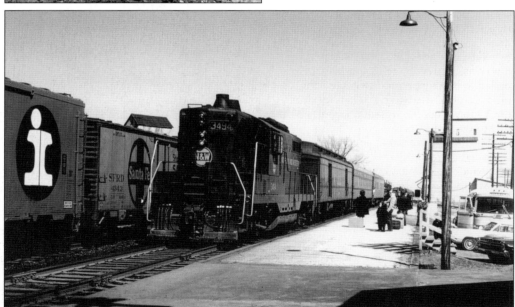

The N&W aggressively sought to discontinue the passenger trains serving central Illinois that it inherited from the Wabash Railroad in 1964, but was sometimes stymied by federal regulators. Such was the case with the Detroit–St. Louis *Wabash Cannonball*, which the N&W tried repeatedly to end. The train, shown in June 1969 at Tolono, survived until the coming of Amtrak in 1971. (Photograph by Dwight Long.)

In railroad parlance, the tower controlling the crossing of the NYC and the NKP in Charleston was known as CO. The tower was thought to be 80 years old when it was demolished in January 1984. Staffed by NKP employees, the tower had a row of levers that operators pushed or pulled to line signals and switches. The photograph above was not taken inside of CO tower but has a similar layout. CO tower operators also controlled nearby crossing gates and, at one time, informed eastbound NYC freight trains what track they would be using in the Mattoon yard. In the photograph at right, CO tower is in its twilight years in April 1977. It is not clear why workers never finished painting the tower. (Above, photograph by James McMullen; right, photograph by Craig Sanders.)

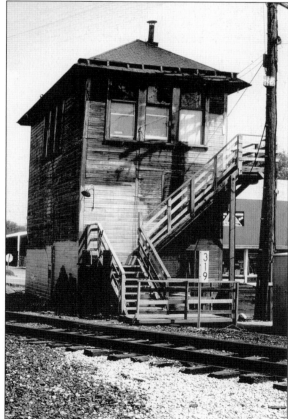

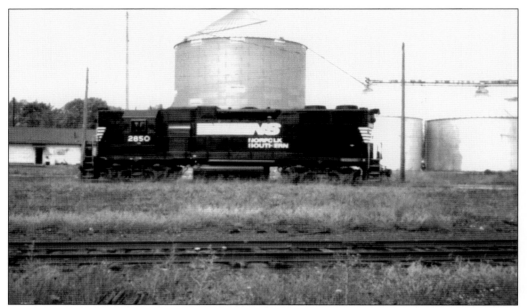

In early 1985, Norfolk Southern Corporation (NS) announced it would abandon the former NKP between Linden, Indiana, and Cowden, citing a 1983 operating loss of $721,000 due to lack of traffic. Charleston shippers purchased 33 miles of the line in late 1987 and contracted with IHR to run it. A lone locomotive idles in the Charleston yard in the waning NS days. (Photograph by Leland Warren.)

The Eastern Illinois Railroad (EIR) has operated the former NKP between Metcalf and Neoga since 1991. EIR interchanges at Metcalf with CSX Transportation and at Neoga with CN. The former NKP has been removed between Metcalf and Frankfort, Indiana, and between Neoga and Coffeen. An EIR train is shown at Neoga with a string of grain hoppers. (Photograph by Sheldon Lustig.)

Six

EFFINGHAM RAILROADS

The IC's Chicago–New Orleans main line and the Pittsburgh–St. Louis route of the PRR crossed in Effingham. The IC and the Wabash Railroad had branches that terminated in Effingham.

The first settlement was named Wehunka, for a Native American chief. Platted in 1854, the village was named Ewington and later Broughton. Situated on the National Road, the town boomed after the arrival of the IC. It was renamed Effingham in 1859, when it became the seat of Effingham County. The name honors either Lord Edward Effingham, a British nobleman who resigned his commission in the British army in 1775 rather than serve in the war against the colonies, or Gen. Edward Effingham, a veteran of the 1832 Black Hawk War, who surveyed Effingham County.

The St. Louis, Vandalia and Terre Haute Railroad was chartered on February 10, 1865, and leased by the Terre Haute and Indianapolis Railroad in 1868. The first train arrived in Effingham on April 26, 1870. The line opened between St. Louis and Terre Haute on June 12, 1870. Long aligned with the PRR, the Terre Haute and Indianapolis Railroad was dissolved on December 31, 1904, and its assets transferred to the Vandalia Railroad, whose stock was controlled by the PRR.

The narrow-gauge Springfield, Effingham and Southeastern Railway formed in 1868 and opened between Effingham and Switz City, Indiana, on December 5, 1880. The IC leased its successor company, the Illinois and Indiana Railroad, in 1900 and provided funding for an extension to Indianapolis. Effingham-Indianapolis passenger service began on December 17, 1906.

The Bloomington and Ohio River Railroad was chartered on March 10, 1869, to build between Effingham and Bloomington. A merger created the Chicago and Paducah Railroad (C&P), whose ambitions included building to Louisville, Kentucky. The C&P opened between Streator and Altamont in western Effingham County on June 29, 1874. Service on the Effingham branch, which separated from the Altamont branch at Shumway, began in February 1876. The Wabash acquired the C&P on April 5, 1880, and hoped to extend it to Cincinnati. But that never occurred.

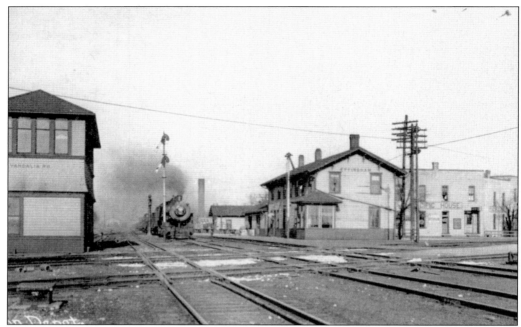

The IC and PRR shared a passenger station in Effingham. The photograph above shows the original union depot, a wooden frame building, alongside the IC tracks. The tower at left controlled the crossing of the two railroads. The train is a southbound IC train. The photograph below shows the modern-day union depot. Out of view to the left is the tower that continued to control the signals at the crossing. Later the interlocking machine controlling the crossing was moved inside the depot and the tower demolished. IC employees lined the signals, wrote orders for trains on both railroads, and sold passenger tickets. This latter arrangement lasted a few years into the Amtrak era. (Above, courtesy of John Fuller collection; below, courtesy of Mark Camp collection.)

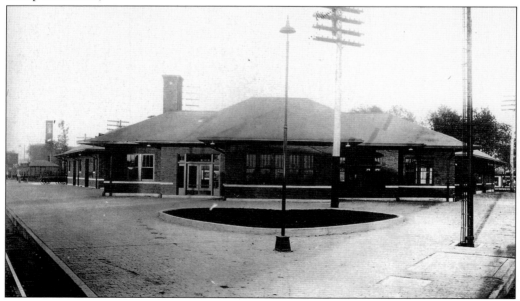

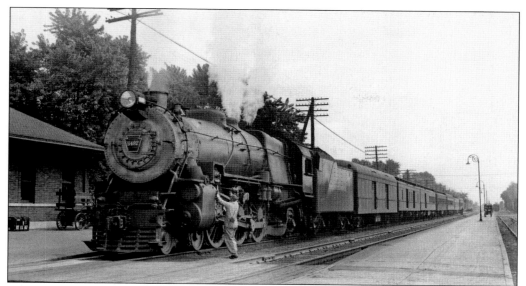

The PRR dominated the St. Louis–New York passenger market because it had a more direct route than the NYC or B&O. The PRR fleet included the *Spirit of St. Louis*, *Penn Texas*, *American*, *Jeffersonian*, and *St. Louisan*. Locomotive 5487 is pulling a seven-car train on August 31, 1937, at Effingham. (Photograph by Otto Perry, courtesy of Denver Public Library, Western History Collection, OP14417.)

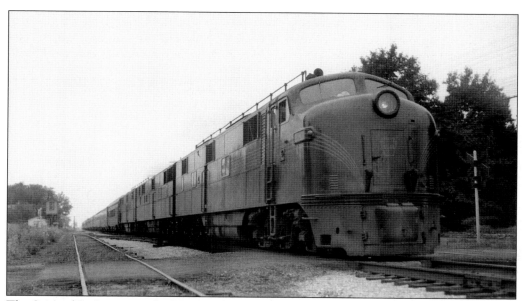

The *Spirit of St. Louis* was the PRR's premier St. Louis–New York train. Launched on June 15, 1927, as an all-Pullman train, the *Spirit* received coaches in 1932. Four years later it was placed on a 20-hour schedule. A 12-car *Spirit* is at Effingham on June 29, 1951, having been re-equipped two years earlier. (Photograph by Otto Perry, courtesy of Denver Public Library, Western History Collection, OP 14451.)

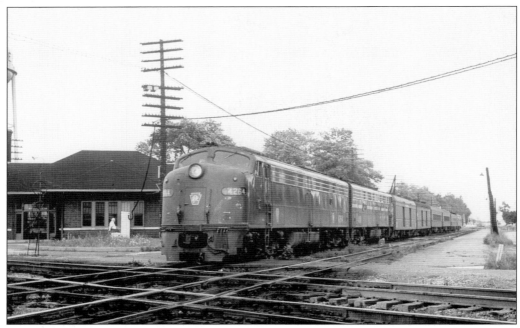

The PRR and Missouri Pacific Railroad established a New York–Texas train, the *Sunshine Special*, on July 7, 1946, that ran straight through St. Louis. Missouri Pacific Railroad soon lost enthusiasm for the train, which averaged 18 passengers a day through St. Louis. Through train operation ended on April 25, 1948, in favor of interchanging sleeping cars. The PRR on December 12, 1948, renamed its portion of the *Sunshine Special* the *Penn Texas*. The New York–Texas through sleepers ended June 26, 1961. Patronage had fallen considerably by the time these images of No. 3, the westbound *Penn Texas*, were recorded at Effingham on July 27, 1968. Penn Central Transportation Company said No. 3 lost $833,213 in 1968 and that only 33 passengers a day disembarked from the train west of Richmond, Indiana. No. 3 was discontinued in June 1970. (Photographs by James McMullen.)

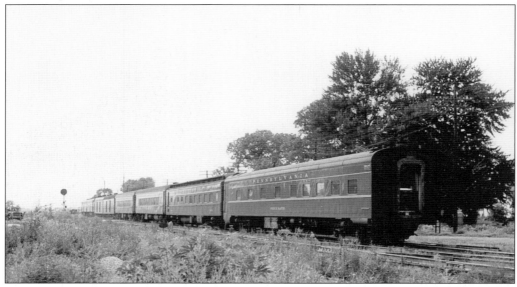

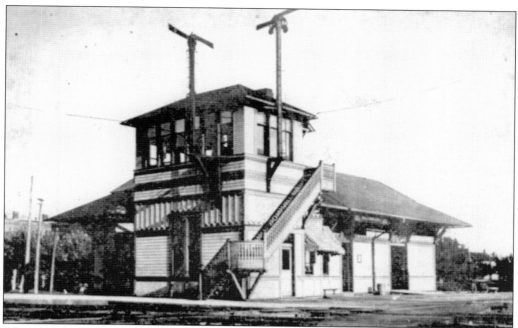

Altamont, located 12 miles west of Effingham, had four railroads: the PRR, C&EI, B&O, and a stub end Wabash Railroad branch. The photograph above shows Altamont Union Station in the early 20th century. The C&EI paralleled the PRR westward for six miles to St. Elmo before crossing it. The St. Elmo station is shown in the photograph below with the tower controlling the crossing in the distance. The B&O branch, which operated between Beardstown on the Illinois River and Shawneetown on the Ohio River via Springfield, is now gone. Passenger service on the branch—a motor car between Flora and Beardstown—lasted through March 1951. The Wabash Railroad branch was removed in the 1930s. Union Pacific Railroad now operates the former C&EI route. (Courtesy of John Fuller collection.)

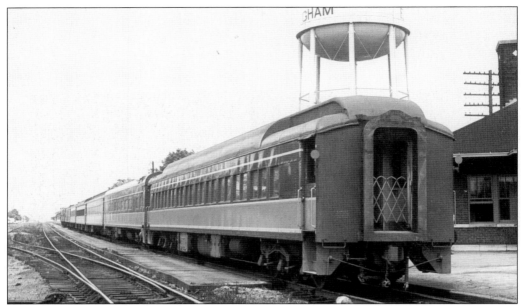

The IC shortened the routes of two pairs of Chicago–New Orleans passenger trains in the 1960s. The trains were revamped as part of IC's Chicago–Carbondale "Mini-Corridor," receiving faster schedules by eliminating some stops. No. 28, shown northbound at Effingham on July 27, 1968, was now named the *Campus*, but until March 12, 1967, it had been the New Orleans to Chicago *Creole*. (Photograph by James McMullen.)

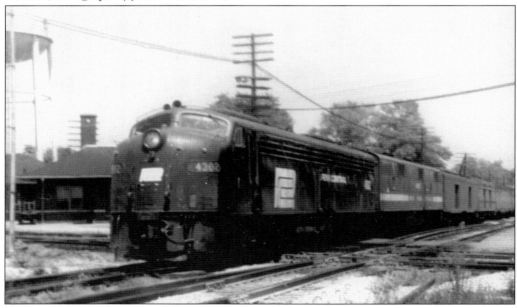

Penn Central Transportation Company passenger trains on the St. Louis line were, in the words of the Interstate Commerce Commission, consistently dilapidated, dirty, and late. The eastbound *Spirit of St. Louis* is shown boarding at Effingham on July 13, 1969. Penn Central Transportation Company tried to discontinue the train in April 1970, but a court order kept St. Louis line passenger trains operating until the 1971 advent of Amtrak. (Photograph by Jeff Pletcher.)

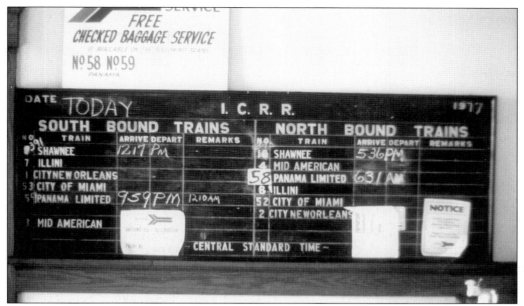

The IC exited the intercity passenger business with the May 1, 1971, inception of Amtrak. The train bulletin at Effingham Union Station shows how Amtrak kept four IC trains, but eight others were discontinued. Deteriorating track conditions prompted go-slow orders that resulted in delays for Amtrak trains on the IC. On this 1977 day, the southbound *Panama Limited* is two hours late. (Photograph by Jeff Pletcher.)

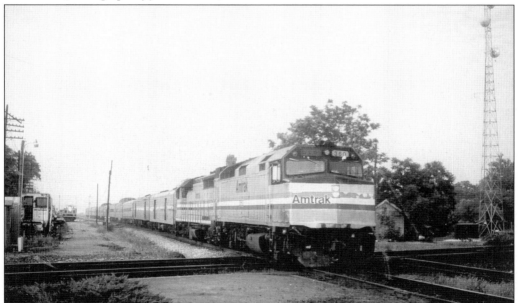

Amtrak's *Panama Limited* received new Amfleet coaches in January 1977 even though those cars were not designed for long-distance travel. Four years later, when it was renamed the *City of New Orleans*, the train received rebuilt Heritage fleet coaches, most of which had been built in the 1950s. An 11-car northbound *City of New Orleans* is shown arriving at Effingham on June 17, 1990. (Courtesy of Marty Surdyk collection.)

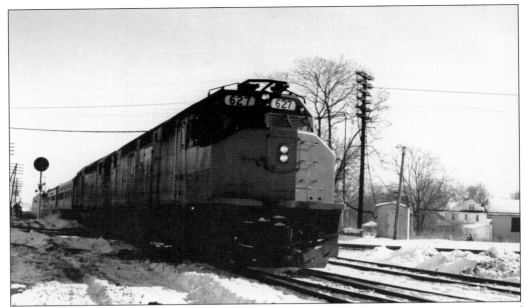

Amtrak combined Penn Central Transportation Company's New York–St. Louis *Spirit of St. Louis* and Missouri Pacific Railroad's westbound No. 15 and eastbound *Missouri River Eagle* between St. Louis and Kansas City. The train was renamed the *National Limited* on November 14, 1971, a name once used by a B&O St. Louis–Washington train. The westbound *National Limited* is shown at Effingham in January 1977. (Photograph by Craig Sanders.)

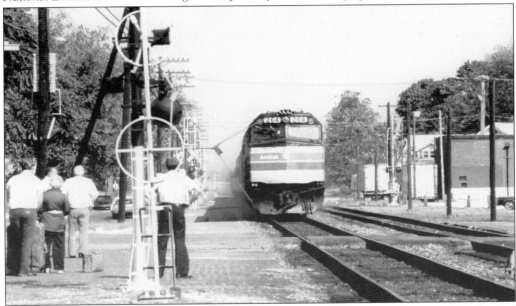

For much of its life, bad track and trouble-prone equipment plagued Amtrak's *National Limited*. Relief arrived on August 13, 1978, in the form of Amfleet coaches, a diner-lounge, and rebuilt sleeping cars. However, the *National Limited* completed its final trips on October 1, 1979, victimized by a route reduction program. The westbound *National Limited* is arriving in Effingham in September 1979 behind two F40PH locomotives. (Photograph by Craig Sanders.)

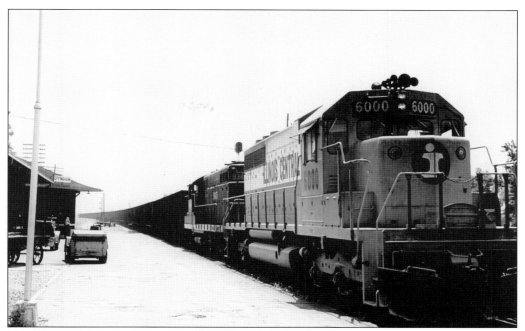

The IC took delivery in December 1967 of six SD40 freight locomotives from the Electro-Motive Division of General Motors Corporation. The first new six-axle diesel freight locomotives purchased by the railroad did not come with dynamic brakes. The locomotives were rated at 3,000 horsepower. No. 6000 is shown leading a northbound coal train past the passenger station at Effingham on July 7, 1968. (Photograph by James McMullen.)

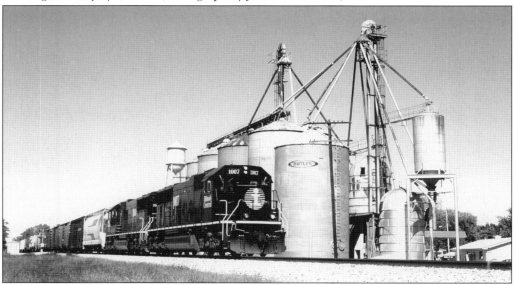

In early 1995, the IC ordered 20 SD70 locomotives from the Electro-Motive Division of General Motors Corporation. Unlike other locomotives in this model line, the IC units had low noses and a traditional control stand. The railroad ordered another batch of 20 SD70 locomotives in 1998. No. 1007, built in September 1995, leads a manifest freight at Watson, located six miles south of Effingham. (Photograph by Marty Surdyk.)

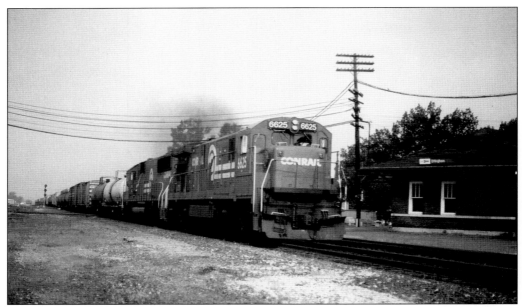

Consolidated Rail Corporation operated the former PRR line between St. Louis and Terre Haute between April 1, 1976, and May 31, 1999. Many of the trains on Conrail's westernmost route interchanged with western railroads at St. Louis. One pair of trains interchanged at Effingham with the IC. An eastbound manifest freight train passes Effingham Union Station on June 17, 1990. (Courtesy of Marty Surdyk collection.)

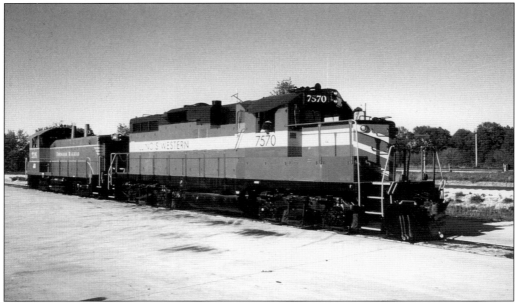

The Effingham Railroad serves an industrial park on the city's southwest side. It interchanges freight cars with CSX Transportation and CN, and spots the cars for loading or unloading by businesses in the park. Effingham Railroad managers note that it performs switching services that CSX and CN do not want to provide. The railroad's motive power fleet is shown in May 2003. (Photograph by Paul Burgess.)

Seven

OTHER AREA RAILROADS

East central Illinois was laced with railroads. Some were trunk routes linking Chicago or St. Louis with the East and South. Others were branch lines dependent upon agriculture products and tended to be busiest during the fall grain-harvesting season.

Among these railroads were the B&O, C&EI, Wabash Railroad, and PRR. The B&O had two routes in the region: Springfield–Indianapolis via Tuscola, and Beardstown–Shawneetown via Pana and Altamont. The C&EI passed through Tuscola, Arthur, and Sullivan before splitting at Findlay into lines for St. Louis and southern Illinois. The Wabash had branches ending in Effingham and Altamont that also served Windsor and Sullivan. The PRR had a branch between Terre Haute and Peoria that passed through Oakland, Arcola, and Arthur. The NYC had a Chicago–Cairo route via Paris.

Changing traffic patterns and public policies that encouraged railroad abandonment in the 1980s led to the demise or truncating of some of these lines. Grain shipments had sustained some routes, but the track had not been built for 100-ton hopper cars. The trunk railroads that owned these branches were unwilling to spend millions to rebuild routes that produced relatively little business. The short-line owners who purchased or leased some of these branches lacked the capital for such renovations.

Three routes remain active. CSX Transportation owns the former NYC line between Paris and Danville and the former B&O line through Tuscola. The latter route has been abandoned west of Decatur and east of Hillsdale, Indiana. The former NYC is gone south of Paris. Both routes see moderate traffic, much of it originating or terminating at industries in Decatur or Paris.

The C&EI merged with the Missouri Pacific Railroad on October 15, 1976, and its southern Illinois line became part of a Chicago-Texas route that bypassed St. Louis. The Missouri Pacific Railroad merged with the Union Pacific Railroad on December 22, 1982. The former C&EI lines in the area have remained intact and today are busy freight routes.

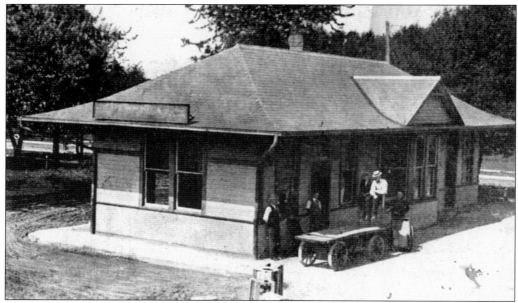

The PRR branch between Terre Haute, Indiana, and Peoria was the brainchild of Terre Haute businessmen. Although the idea for the railroad surfaced before the Civil War, the line was not completed until late 1874. The founders probably hoped to capture some of the substantial industrial traffic in Peoria and Decatur and to supply coal to those industries. But the railroad was poorly constructed and faced tough competition from better-built competitors. Passenger service on the branch lasted through April 24, 1949. The daily (except Sunday) train left Decatur at 12:30 p.m., ran to Paris, and returned to Decatur that night at 9:30. The Arcola station is shown in the photograph above. The Oakland station, shown below, is among the few remnants left of the railroad. (Above, courtesy of Mark Camp collection; below, photograph by Craig Sanders.)

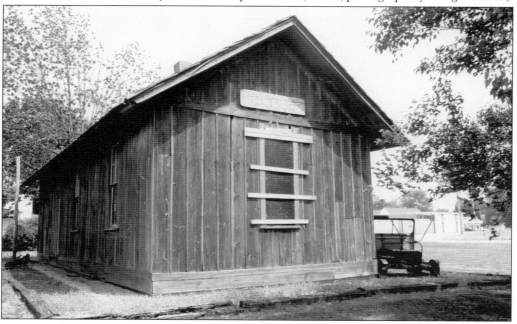

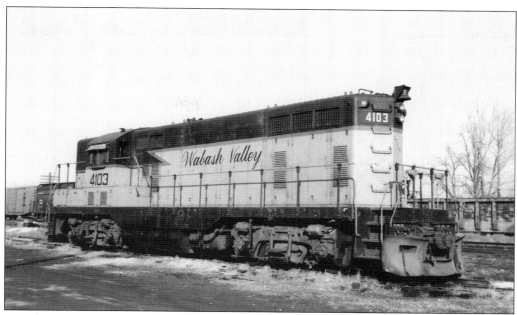

Two short-line railroad companies operated the former PRR line between Paris and Decatur through the 1980s. The Wabash Valley Railroad began operations in 1978 but ceased service after the State of Illinois ended its operating subsidy of the route. The Prairie Central Railway (PC) was the next operator of the line, but quit after the ICG embargoed a PC train at Hervey City after the PC failed to pay rent. In the photograph above, a Wabash Valley Railroad locomotive idles between assignments in Decatur on January 22, 1981. In the photograph below, a PC train is crossing WABIC intersection in Decatur. It was common for short-line railroads to lease or purchase locomotives from a Class I railroad, in this case Consolidated Rail Corporation. (Photographs by David Tiffany.)

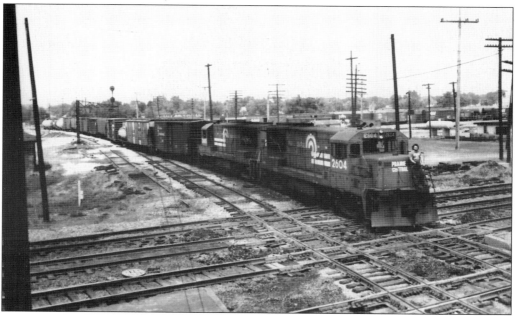

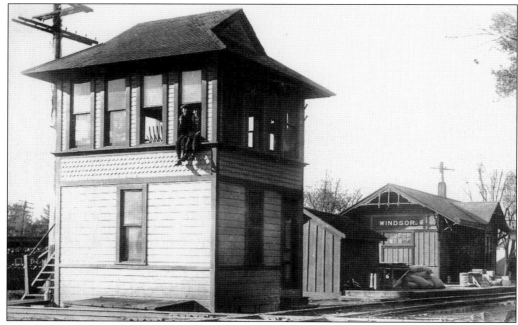

The Wabash Railroad in the 1930s operated Bement–Effingham passenger trains 30 and 31 while Bement–Altamont freight trains 70 and 71 carried passengers. Rather than repair a bridge over the Okaw River, the line was abandoned south of Sullivan. The last train operated on October 17, 1938. This tower guarded the Wabash Railroad–NYC crossing in Windsor. The passenger station is also shown. (Courtesy of Bob Bennett collection.)

Dispatchers used centralized traffic control (CTC) panels such as this one in the Wabash Railroad's division headquarters in Decatur to remotely control switches and signals. The NYC installed a similar CTC panel in Mattoon in 1949. The second CTC operation on the NYC, it initially controlled 87 miles between Sanford, Indiana, and Pana but expanded in 1958 to include track west of Pana. (Photograph by James McMullen.)

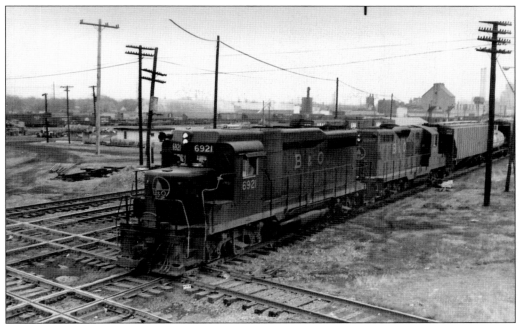

The Indianapolis, Decatur and Western Railroad (ID&W) opened on August 10, 1873, between Decatur and Montezuma, Indiana. It reached Indianapolis in 1880. The ID&W later acquired the Springfield and Decatur Railway, which operated between its namesake cities. A consolidation with the Cincinnati, Hamilton and Dayton Railroad on November 2, 1902, created a route extending between Springfield and Hamilton, Ohio. The B&O acquired the route in 1927 and began a through sleeping car between Springfield and Washington, D.C. Passenger service ended west of Decatur in July 1940, and between Decatur and Dana, Indiana, in February 1950. In the photograph above, a westbound B&O train crosses the IC in Decatur on December 30, 1977. In the photograph below, a CSX Transportation train works at Tuscola in summer 1989. (Above, photograph by David Tiffany; below, photograph by Robert Oliphant.)

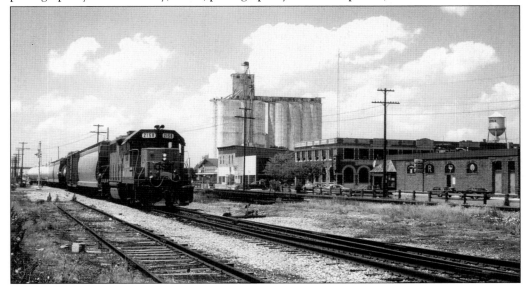

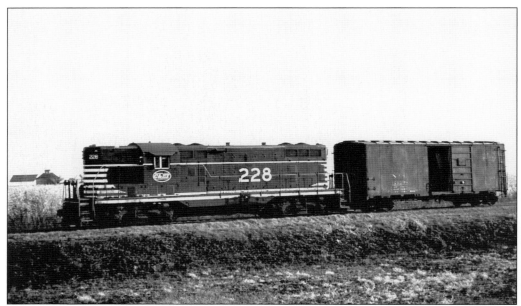

The C&EI ordered 30 GP7 diesel locomotives from the Electro-Motive Division of General Motors Corporation in 1950–1951 as replacements for soon-to-be-retired steam locomotives. The "geeps" continued in service through the 1970s. No. 228 has a light load in this view recorded on October 19, 1966. The C&EI served such area towns as Tuscola, Arthur, Findlay, Sullivan, and Shelbyville. (Photograph by James McMullen.)

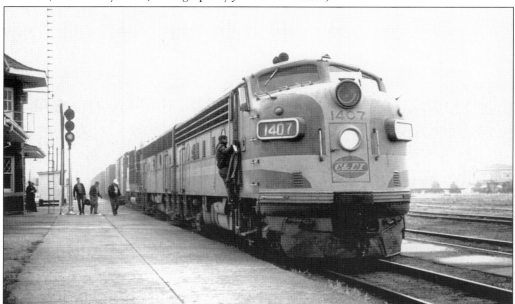

Villa Grove hosted a division headquarters and roundhouse of the C&EI. The railroad's major shops were located in Danville. A southbound freight train is changing crews at Villa Grove on April 30, 1966. No. 1407 is an F3A built in December 1948 by the Electro-Motive Division of General Motors Corporation. The C&EI retired its last steam locomotives in May 1950. (Photograph by James McMullen.)

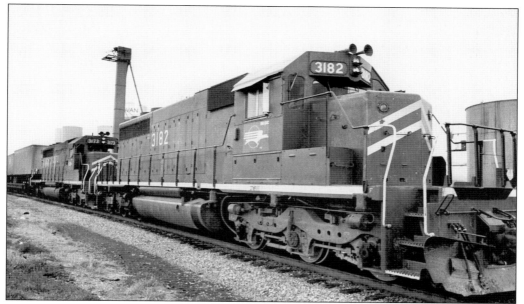

The C&EI line through central Illinois was built from Danville to southern Illinois in the 1880s. The Missouri Pacific Railroad secretly purchased C&EI stock in the early 1960s and took control of it on May 12, 1967. C&EI rolling stock received the Missouri Pacific Railroad buzz saw logo, but with C&EI initials. A southbound Missouri Pacific train is at Sullivan in April 1978. (Photograph by Craig Sanders.)

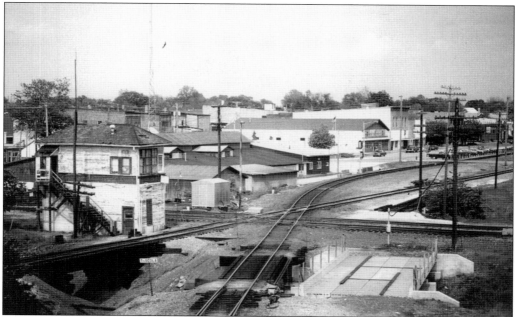

TY Tower in Tuscola guarded the five-diamond crossing of the IC, B&O, and C&EI. Tower operators were IC employees. The crossing was simplified in the early 1990s by combining the former B&O and C&EI tracks into one track that crossed the double-track IC. The empty bridge will carry the joint track of the two railroads. (Photograph by Marty Surdyk.)

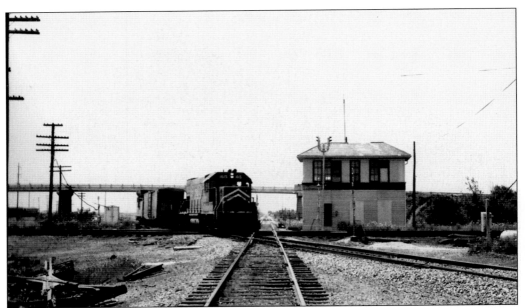

The IC's replacement of double track with single track and passing sidings controlled by CTC led to the closing of TY Tower in Tuscola in October 1992. The tower was demolished in May 1994. Many railfans probably remember tower operator Bob Moomaw, who invited them in for visits. A Missouri Pacific Railroad local freight train passes the tower on July 2, 1981. (Photograph by David Tiffany.)

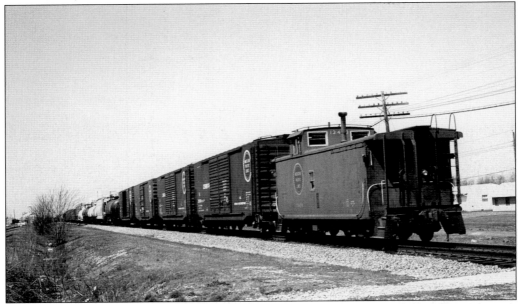

The C&EI was a regional railroad primarily serving Illinois and Indiana that by the 1960s was finding it increasingly difficult to survive in a changing railroad environment. The Missouri Pacific Railroad was seeking an entrance to the Chicago railroad gateway and acquired the C&EI to achieve that end. A Missouri Pacific freight train is shown at Tuscola on April 11, 1971. (Photograph by James McMullen.)

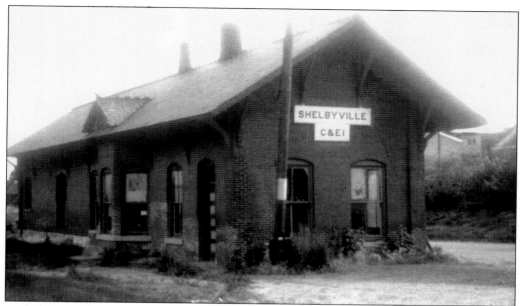

In the early 1950s, four C&EI passenger trains operated between Chicago and southern Illinois through Shelbyville. The overnight Chicago–Thebes *Silent Knight* lost its sleepers on April 24, 1949, and began terminating at Marion. It ended on December 16, 1954, by which time its southern terminus was Salem. The *Meadowlark* between Chicago and West Vienna made its final trips on January 5, 1962. (Photograph by John Fuller.)

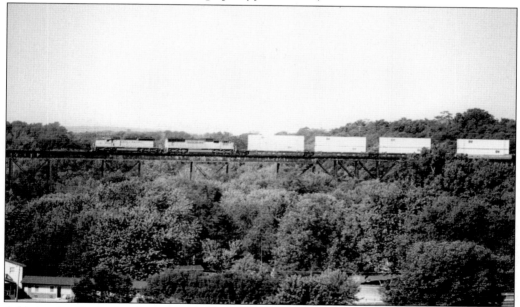

A Union Pacific Railroad train at Shelbyville in June 2003 crosses the former C&EI Kaskaskia River bridge, one of the largest in the state. Historically this line carried southern Illinois coal, and bridge traffic interchanged with the St. Louis Southwestern Railway (Cotton Belt) and the St. Louis–San Francisco Railway (Frisco). Today the Union Pacific Railroad owns lines of all these railroads. (Photograph by Paul Burgess.)

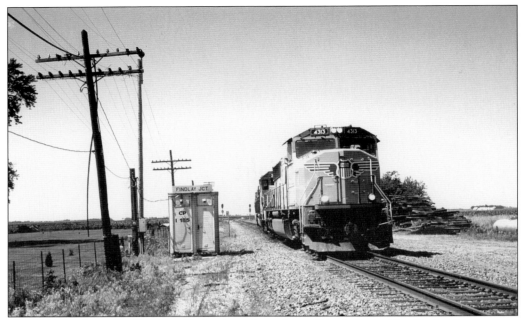

The C&EI split at Findlay into St. Louis and southern Illinois lines. The St. Louis route was built in 1902 between Findlay and Pana, reaching St. Louis over the Big Four Railroad. The final C&EI St. Louis passenger train, the *Cardinal*, ended on April 21, 1949. A set of Union Pacific Railroad locomotives comes off the St. Louis line in June 2003. (Photograph by Paul Burgess.)

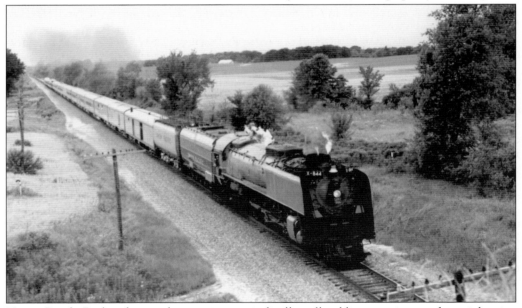

Union Pacific Railroad steam locomotives periodically pull public excursions and special trains throughout its system. No. 844 twice visited central Illinois in the early 1990s in conjunction with National Railway Historical Society conventions in St. Louis (1990) and Chicago (1992). No. 844 pulled excursion trains over the former C&EI as part of both conventions and is shown near Pana in 1990. (Photograph by Edward Ribinskas.)

Eight

THIS WAS A
RAILROAD TOWN

Mattoon and Charleston began declining as railroad centers in the 1950s as diesel locomotives replaced steam locomotives. Unlike steam engines, diesels did not need to be serviced as often en route. As railroads consolidated repair and service facilities, many a roundhouse closed, including the NKP roundhouse in Charleston and the roundhouses of the IC and NYC in Mattoon. All three have been demolished.

Another far-reaching change occurred in the freight business as trucks siphoned away much of the short-haul and less-than-carload business that had been railroad mainstays for decades. Trucks were faster and more flexible. Railroad managers decided that the business still available at grain elevators, scrap yards, and small industries was no longer worth the cost of providing.

Railroads reduced expenses by consolidating office functions. The NYC announced on October 3, 1964, that it would combine the Illinois division, headquartered in Mattoon, with the Indiana division, based in Indianapolis. Dispatchers and managers in Mattoon were moved to Indianapolis. Following the February 1, 1968, merger of the NYC and the PRR to form Penn Central Transportation Company, the crew change point in Mattoon was eliminated on April 28 and the employees transferred to Indianapolis.

Increasingly, railroad managers and government policy makers viewed the cost of lightly used routes as needlessly weighing down the railroad industry. Route abandonment and sales to short-line operators became widespread. The former NYC route serving Mattoon and Charleston was removed in late spring 1983. Also being abandoned has been much of the IC's Mattoon–Evansville line and the former PRR's Terre Haute–Peoria line. Portions of the former NKP's St. Louis line have been pulled up, although a short-line operator, the EIR, has preserved the track in Coles County.

Railroad employment in Mattoon and Charleston today is miniscule, and railroads serve few shippers. The former IC's Chicago–New Orleans main line remains busy, but most trains merely pass through Mattoon. The era when Mattoon and Charleston were substantial railroad towns has passed.

Consolidated Rail Corporation told the Interstate Commerce Commission on May 1, 1981, it was studying abandonment of its line serving Mattoon and Charleston. A La Salle short-line railroad expressed interest in operating the line but refused to commit to providing service until receiving commitments from shippers, who in turn wanted to see rates before making commitments. The La Salle short line primarily was interested in grain shipments, which had been sparse on the route in previous years. The Interstate Commerce Commission approved abandonment in March 1982, and workers began removing the 127-year-old railroad. In the photograph above, a rail train picks up the rail west of Mattoon in May 1983. The photograph at left shows the main line rails having been cut just west of Logan Street in Mattoon. (Above, photograph by Craig Sanders; left, photograph by Leland Warren.)

Much of the former NYC right-of-way in Coles County is now used by a utility company, but a trail for hikers, bikers, and runners was established where trains once ran between Mattoon and Charleston. The trail begins in Mattoon at Tenth Street and extends to Charleston, where the trail is shown in a view looking eastward in July 2007. (Photograph by Craig Sanders.)

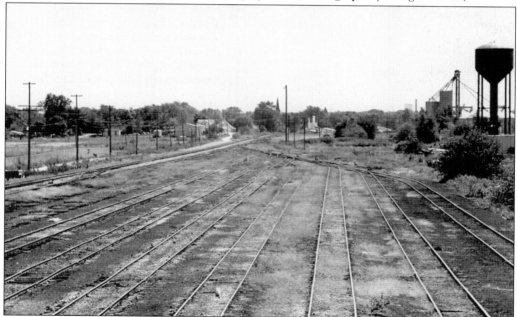

The former NKP yard in Charleston is empty in this 1976 view looking southward. Most of the tracks in this scene have since been removed, but a portion of the yard is used today by the EIR, a short-line operator based in Charleston that serves shippers on the former NKP between Neoga and Metcalf. (Courtesy of Nancy Easter-Shick collection.)

The IC's Mattoon–Evansville line was removed between Lerna and Newton in late 1982. A grain elevator at Jones purchased the track between Mattoon and Lerna. However, the track between Lerna and Newby was removed in 2002. This view shows the end of track at Newby, a village once known as Montgomery. Little is left of Newby today other than a cemetery and farms. (Photograph by Thomas French.)

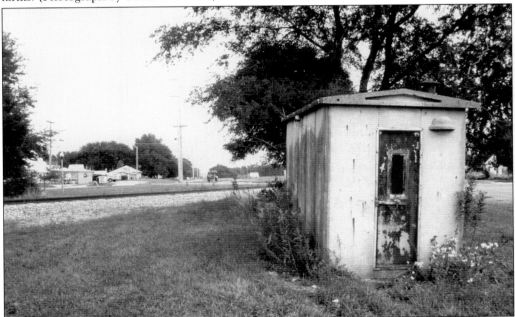

The control box of the former crossing of the IC and NYC at Thirty-second Street in Mattoon is among the few NYC vestiges left. The open area in the background is the site of the former PD&E shops (later used by the IC). The roundhouse was demolished in 1963. The last shops building was razed in 1966. (Photograph by Craig Sanders.)

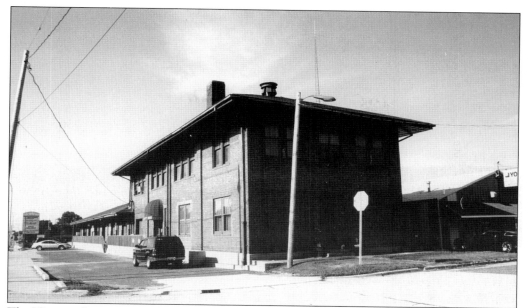

The IC opened a two-story freight station on South Eighteenth Street (now Lake Land Boulevard) in Mattoon in 1906. Two freight rooms were on the first floor, and offices were on the second floor. IC planned to raze the building in March 1982, but a local business owner purchased it. Other businesses, including a drive-in restaurant, have since built where the tracks once were. (Photograph by Craig Sanders.)

The Railway Express Agency building in Mattoon opened in 1918 and was designed to match the Big Four Railroad station located two blocks east. Operating around the clock, the Railway Express Agency facility handled everything imaginable until closing in 1971. It has since been used as a warehouse and was placed on the National Register of Historical Places in 1994. Nonetheless, its fate in 2008 was uncertain. (Photograph by Craig Sanders.)

ACROSS AMERICA, PEOPLE ARE DISCOVERING SOMETHING WONDERFUL. *THEIR HERITAGE.*

Arcadia Publishing is the leading local history publisher in the United States. With more than 3,000 titles in print and hundreds of new titles released every year, Arcadia has extensive specialized experience chronicling the history of communities and celebrating America's hidden stories, bringing to life the people, places, and events from the past. To discover the history of other communities across the nation, please visit:

www.arcadiapublishing.com

Customized search tools allow you to find regional history books about the town where you grew up, the cities where your friends and family live, the town where your parents met, or even that retirement spot you've been dreaming about.